MUSIC TO

DMITRY SAMAROV

"I AM NOT AN ASPIRING
MUSICOLOGIST, NO, NO..."
— Slovenly "SPY SURF"
from We Shoot for the Moon
(SST 1989)

ALSO BY DMITRY SAMAROV:

HACK: STORIES FROM A CHICAGO CAB
WHERE TO? A HACK MEMOIR

ISBN-13: 978-1-948954-09-9
ISBN-10: 1-948954-09-5

Drawn, written, and designed by Dmitry Samarov

Typeset in Helvetica Neue by Max Miedinger
Printed by Ingram Spark

Tortoise Books, Chicago, IL, USA
tortoisebooks.com
dmitrysamarov.com

TABLE.

———

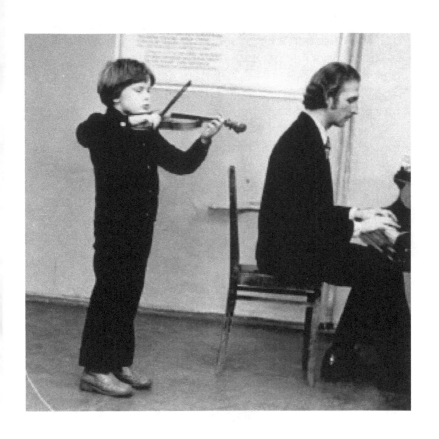

MUSIC & ME

Whenever anyone asks what kind of music I like, I freeze up. The question's always felt too personal when asked by a stranger taking my cab or ordering a drink at my bar, and too open-ended when asked by someone I know. There's too much to say, so I say nothing. Music has haunted me my whole life.

Like most children of Soviet *intelligentsia*, I was forced to start playing a musical instrument when I was five or six. Mine was a piccolo flute. I remember taking it apart and putting it back together, and that its case had a blue velvet lining. I have no memory of making music with it. About a half year after starting to play, my teacher left, and it was determined that I was "too talented" to stay with such a minor instrument. The school decided to "promote" me to violin.

I had a music folder with a flap that tied closed with a ribbon which my father would pull open over and over on the way home from class. That's how I learned to tie my shoes and it's the only positive association I have with music lessons or that instrument. I hated the awkward, uneven way it had to be held and the screeching it made when played badly. Nails on a chalkboard is an angel's aria next to a misplayed violin. It is an unforgiving, neurotic instrument. I hated to even open its case.

After we moved to the United States in 1978 I went through a succession of unfortunate violin teachers. Unfortunate because they had to teach me and deal with my temper tantrums and my all-out effort to play as little as possible. My poor mother, whose unfulfilled

musical ambitions were apparently sated vicariously through my torment, had to deal with a lot as well. I broke two bows flinging them against the wall; that would get me out of practicing, at least for the afternoon. She would try to tape and glue them back together before wasting more money on replacements. I begged to quit every one of the eight years she made me play.

The last teacher I had was a Russian woman who played in the Boston Symphony. I can't say whether she was as uninterested in teaching me as I was in learning from her; it was likely a dead heat. In any case, she never put up much protest when I'd call a half hour before our lesson and cancel so that I could blow the $40 my mother gave me on video games and pizza. It was one of my most successful scams, though I had to be careful not to do it too often and risk getting caught. At fourteen my mother finally gave in and let me stop.

I still occasionally get nervous when hearing a violin. But I wasn't done with music. I spent my first paycheck from my paper route in 1982 on two cassettes: The *Rocky III* soundtrack and *Abracadabra* by the Steve Miller Band. In sixth or seventh grade my best friend's father—an old Deadhead—helped broaden my horizons. Now I was balancing what I heard on 80s Top 40 radio with the Velvet Underground, Captain Beefheart, and the Stooges. Nothing like alternating *Pyromania* with *Trout Mask Replica* to make a strange kid even stranger.

My father was always singing the Soviet songs of his youth, especially while driving. My folks played Vysotsky, Okudzhava, and the Beatles' Greatest Hits on the record player. There was always a soundtrack but little direct communication growing up. The music was what got through to me best anyway.

Boston record stores like Nuggets and In Your Ear were regular spots for spending whatever money I had, whether earned or stolen. I'd buy records, dub them onto cassette, and trade them in for new ones. It was an endless cycle. I still have a crate filled with these cassettes. Many are too worn to play, but they're as close to a diary of my teenage years as I've got.

The movie theater I worked at in the late 80s was run by a man named David Kleiler. His son was in a band called the Volcano Suns. This was likely my first personal contact with a person who made music that I loved. Up until then the idea that the people making the records I bought were people I could talk to never crossed my mind. Through David Jr. I met Peter Prescott. We would talk about movies. He told me once that Martin Scorsese's *New York, New York* was the best film ever made about the musician's life. I'd track him down at whatever record store he was work-ing at in Boston anytime I visited my family.

In 1989, I went to New York, then Chicago for art school, and going to shows remained at least as important as visiting the Met or the Art Institute. I graduated in 1993, moved back to Boston, and started driving a cab. Going to the Middle East, t.t. the bear's, and

other clubs likely saved me from offing myself. As Peter said, "Boston's a good place to be in a funk." I returned to Chicago in 1997 for good, but bands from Boston are still close to my heart.

I had drawn people playing music before, but sometime in the late 90s it became a regular part of my concert-going routine. It was a way to listen better, to make the sounds closer, to bring it more into my own world. The intent of these sketches has never primarily been to nail a likeness but rather to show a bit of what it was like to be in the room with those people on stage on that night.

Once in 2009, Chicago artist Tony Fitzpatrick summoned me to his studio. I was driving him around nearly every day, but that day he needed me to give Lou Reed a ride back to the Trump Hotel. I spent the whole ride downtown silently searching my mind for something to say to the man that wouldn't sound completely sycophantic. What do you say to Lou Reed? I murmured something like, "Thanks for the music," as he was getting out of the cab. I think he thanked me.

A few years back I traded a large drawing for guitar lessons with my friend Bill MacKay. It was odd to hold an instrument again and make sounds come out of it. It was good because it's an instrument whose sounds I actually enjoy. I stopped practicing for lack of time but hope to take it up again one day. Bill tells me I've still got some free lessons coming. One of these days I'll take him up on that.

I've had the good fortune to work with many amazing musicians on record covers, flyers, and assorted other projects. I count many as friends, and usually prefer their company to that of visual artists.

My mother's always told me that I could've chosen either music or painting. Who knows if that's so? All I know is that I can't paint or draw without music playing, and that when someone asks what kind of music I like, I get defensive. More times than not I don't answer at all. It's too personal. If it was asked in the cab, I told them I don't listen to music on the radio, then gritted my teeth and tried to endure the horrible radio music they'd insist on for the rest of the ride. But at the bar where I bartend every Sunday, I choose what comes out of the speakers all night. It's the next best thing to being in some dark club with my sketchbook, absorbed in the sound and feel of a live performance, trying to catch it with a few pen strokes.

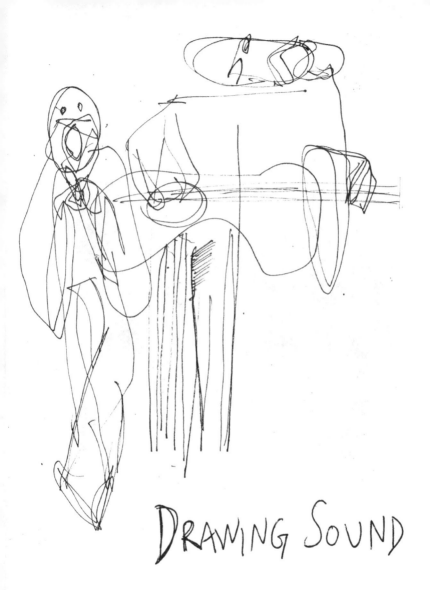

DRAWING SOUND

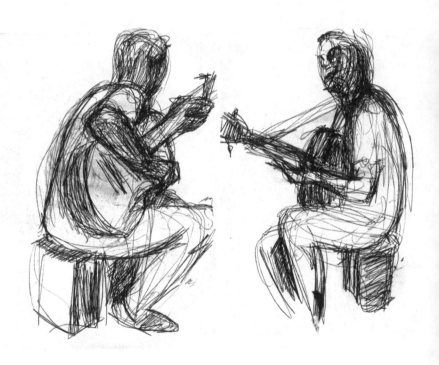

My earliest surviving drawings of people playing music are a series of dashed-off line sketches done inside the Paris Metro in the summer of 1988. My parents had enrolled me in a monthlong art program run by Parsons School of Design. We spent two weeks in the south of France and two weeks in Paris. For some of those kids it was an exotic shopping trip—a few returned with twice as many suitcases as they'd come with—for others, it was a test of their dedication to a thing they'd been told they were good at but had never truly worked at. For a couple of us it was an affirmation of being on the only path available to us.

After drawing or painting in class all day, I'd either go to a museum to sketch from paintings or sculptures—I have a couple sketchbooks full of Brancusis, Zadkines, Soutines, Matisses, Moreaus, Monets, and the like—or I'd wander the streets looking for subjects for my pen.

The buskers were great models since they stayed in one place. But rendering sound is a tricky business. Kandinsky claimed he was evoking music in his abstractions, but to my eye they are more an illustrated idea of music than the feeling of it. His attempt to render sound as symbols is too literal; like a phonetic translation, it kills most of the magic of its source.

I can't pretend that as a seventeen year old I'd figured out how to relate the experience of listening through marks on paper, and I wouldn't make such a claim thirty years on, either. But every time I take out my sketchbook to draw somebody plucking a guitar,

singing into a microphone, or blowing a horn, my primary aim is to quiet my own mind enough to truly listen. Passing a ballpoint pen over a little piece of paper is my way of actively engaging with what the musicians are doing.

There were always street musicians in Harvard Square—a few miles from where I lived then—so when I came back from Paris I would go there when I could, and draw them. The repetitively rhythmic lines of these two sketches suggest I was trying to get some of the energy he was generating, rather than going for any kind of straightforward visual representation.

To this day, there's a tension in my music sketches between depicting physical likeness of the players and portraying the sensation of listening. Sometimes I just want to catch a few of the waves coming at me, other times it's important to capture the personality of the players. Either way, the main thing is to convey some small part of what it was like to be in the same place as the people making the sounds.

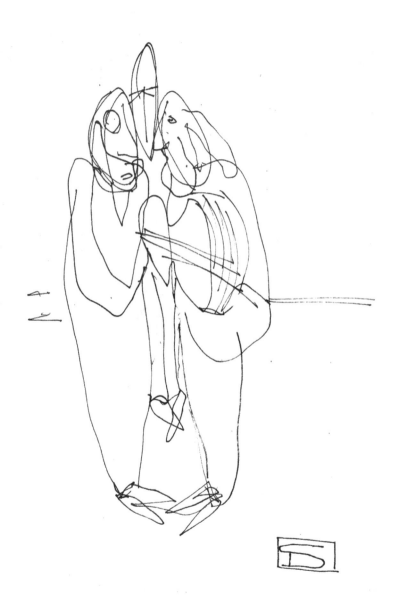

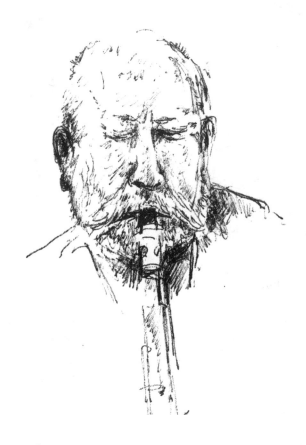

JAZZMEN FROM THE PAST

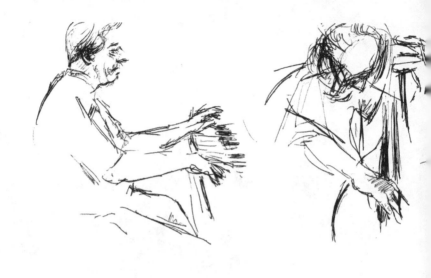

Dave Bryant

One summer Monday in 2016, I went to Experimental Sound Studio, way up the North Side of Chicago, to hear pianist Dave Bryant play a set and give a talk about harmolodics. ESS sits on a sleepy section of Ravenswood Avenue. There's an art gallery in the storefront, a performance space down the hall, and an enclosed garden out back. The place was co-founded by a sound artist named Lou Mallozzi, with whom I'd once taken an art-school course called 4-D.

Dave studied with Ornette Coleman and then played for a time in his band. But my connection to Dave isn't musical. About 30 years ago, when I was still in high

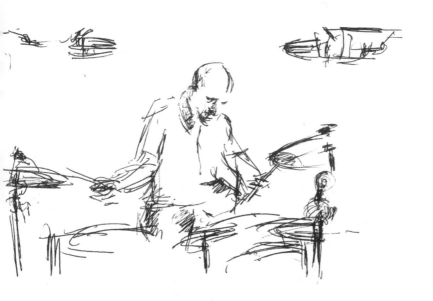

school, he was my manager at the Coolidge Corner Theatre in Brookline, Massachusetts.

At the movie theater, Dave was low-key almost to the point of sleepy. I didn't know much about him until going to a gig of his at a little club in Somerville. Up on stage, leading his trio, Shock Exchange, the mellow, floppy-haired guy I knew was transformed into a wild man. He beat the hell out of those keys. It was one of the first times I realized there could be a difference between how somebody acts at a day job and how they act when doing what they love. Like Flaubert said, "Be regular and orderly in your life, so that you may be violent and original in your work."

I've been out of touch with Dave since Coolidge days, so when I saw his Chicago gig listed I made sure to be there. I even tracked down his website and wrote him an email, but never heard back. There's a good chance he had no memory of me. Lots of high school kids worked at the theater and his time there was obviously just a means to an end.

The music he played this Monday wasn't as raucous as the stuff I recall from that long ago Somerville set but it had an intelligence and grace which only comes from doing something a very long time. The bassist and drummer who backed him were much younger but you could tell they sometimes had to work to keep up with him. After a short break he came back out and gave an hour-long talk about the music philosophy Coleman had taught him. A lot of the technical stuff went way over my head, but the stuff about wrestling with tradition and keeping engaged creatively in every waking moment definitely hit the mark.

Afterwards I planned to come up and introduce myself but thought better of it. Even if I prodded him into remembering me, what would be the point?

To remind him of a time he had a shit day-job with a bunch of high schoolers? I was just happy he was still making music.

Ran Blake

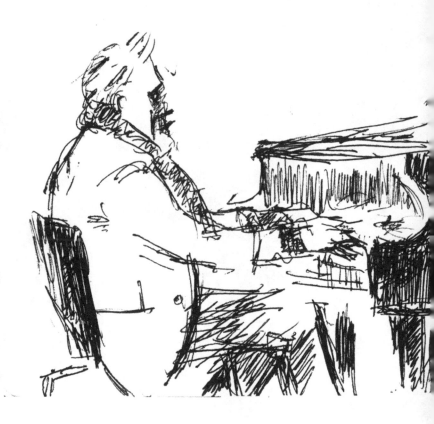

Ran Blake's music is a mix of jazz and classical sounds. I first heard of him back in high school from Dave Bryant but never got a chance to catch him till he came to Chicago in 2016. He played some standards but even the most recognizable melodies were mutated to fit his own

voice. Blake was 80 years old and needed a walker to get to the piano, but once he hit the keys all frailty flew out the window. He made it clear that old age doesn't have to mean retreat, defeat, or diminishment of creative power. He showed me a way to keep going.

Joe Jackson

Joe Jackson is another one from way back who I didn't see live till recently. "Steppin' Out" and "Breaking Us in Two" in particular are songs lodged so deep I don't remember life without them.

Thalia Hall is about a mile and a half from my place in Bridgeport, so I figured if the show was depressing I could just leave. Thalia is a great place to hear music, but also always bittersweet to visit because it's such a herald of Pilsen's gentrification.

It's dangerous to go to a concert like this. Dangerous because the relationship with the music is so intense that having a possibly lesser rendering of it is bound to wreck a heretofore unassailable memory. But as soon as Jackson sat down at the keyboard and started into "It's Different For Girls," I had tears streaming down my face.

He didn't do all the songs I wanted, and he changed the running bass line in "Steppin' Out," saying it was a cheesy 80s arrangement. But maybe expecting to have every memory matched to the last note would've been too much to ask.

There was a top hat sitting next to his seat and I wondered whether he was saving it for a dance number, but late in the show he picked it up, reached in, and took out a slip of paper, explaining he chooses a different cover to do each night this way. That night it was a vocal version of "The Peter Gunn Theme" he'd recently learned from Sarah Vaughn.

I walked out of Thalia and biked the mile and a half home, thinking about how many gaps in time and space Jackson's music nullified that night. I first knew these songs in Boston in the 80s as a teenager and now, pedaling Chicago streets as a middle-aged man, they're still with me, as if newly-formed.

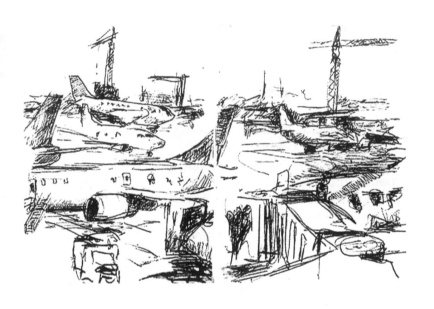

EAST COAST to CHICAGO

Cheater Slicks Slept at My House Last Night

Tom Shannon emailed one afternoon asking if I knew a place his band could crash after their show in town. They were driving in from Columbus to play at the Empty Bottle that night and needed somewhere to sleep before driving back Saturday morning. I thought about it a minute or two, then wrote back that they were welcome to stay at our house. It was the first place I've lived where offering hospitality to out-of-town guests was an option.

I first saw Cheater Slicks at the Rat in Boston in 1988 or '89. They'd only been together a year or so. My friend Ben took me to the show. He was in his twenties and knew about all the cool bands; I was just finishing high school and didn't know much of anything. I remember them complaining on stage that their bass player had quit. It was two guitarists and a drummer and it was loud. The roots of the songs were simple garage rock but they took it other places.

There's no good way to describe the music you love. Just as a painting can only be painted, a song can only be sung. Any effort to explain has to fall short, otherwise, why bother doing it? I'll just say that I've been a fan since that night.

After graduating from art school in Chicago, I moved back to Boston and started driving a cab. Cheater Slicks were one of the bands that helped me

live through those low years. Few bands communicate the frustration and horror of everyday survival quite like them. Fed up with Boston, we both moved to the Midwest; they moved to Columbus, while I moved back to Chicago. They didn't play in town much but I got every record they put out.

When MySpace came around they were one of the first bands I followed. Eventually, Tom (one of the guitarists) and I began to correspond. One of the great things about getting older is that sometimes you get to meet the people whose work you admire. The idea that you can just have a conversation with the people making the magic on stage is still sort of a mindfuck to me but I'm happy to accept it when it happens. In 2007, Cheater Slicks were celebrating their twentieth anniversary in Columbus and I drove my rented Yellow Cab all the way from Chicago to be there.

I've done a couple of sketches of them playing and they liked the last one well enough to use on the insert for their record, *Reality is a Grape*, in 2013. It's another great thing about getting older: you get to work with people you admire. If you had gone back to the Rat, tapped 18-year-old-me on the shoulder, and told him that one of his doodles would become their album art, he'd have told you to get out of town.

Friday night at the Bottle, Tom came up to say hello while the first opening band was just starting to play. He invited me to go hang out downstairs in the green room. Tom's brother Dave, the other guitarist,

was down there smoking and having a beer. Dana Hatch, the drummer, turned up as well. So much of playing a gig out of town seems to be just sitting around and waiting. Still, it was good to hang out, and sort of a treat to be in a room filled with cigarette smoke—a novelty occurrence these days. (Even though I quit years ago, nostalgia nips when you smell the smell.)

The set they played that night was something.

As the years have gone by they've gotten looser and more abstract. The basis is still simple rock-n-roll

but there's more space and improvisation to comple-
ment the noise and feedback. It looks like they enjoy it
more, too. But maybe I'm just reading my own feeling
into it. I can say that they don't clear a room out like they
used to. Maybe a few more people are finally catching
on.

Afterwards, they followed me in their minivan, elev-
en miles south down Western Avenue. We parked them
in the garage so they wouldn't have to unload their gear
for the night, and went inside the darkened house.

Tom immediately made himself at home on the couch, while Dana took the guest bedroom, and Dave got the air mattress in the room with my paintings. The next morning my girlfriend and I took them to Bialy's on 95th Street in Evergreen Park. Outside, afterwards, they gave me a t-shirt and we all said our goodbyes. They left in time to make it back to Columbus for dinner.

When we got back home I noticed a black undershirt in the guest bedroom. I asked Shay about it and she said it wasn't hers. Seems Dana left it. If someone had told me even ten years ago that people that made records I listen to over and over would be leaving clothes at my house some day, I wouldn't have believed them for a second.

I mailed it back a week or two later.

Arto Lindsay

I went to see Arto Lindsay in 1989 at the Knitting Factory on Houston Street in New York City sometime during my six-month stay in the city while attending Parsons School of Design. Then, I didn't see him play again for twenty-eight years. The Knitting Factory was a down-town club for experimental music. I faintly remember the

set: jagged guitar sounds. I was nineteen and had no friends in the city. I'd never be hip enough for that spot but I was trying.

I wonder what I knew about Arto at that point. Probably that he'd been in the Lounge Lizards with John Lurie, and not much else. I used to look through the listings in the Village Voice and go see anybody whose name I recognized. I saw the A-Bones play a Halloween show before a screening of Hammer Films' *Dracula A.D. 1970*, in which Christopher Lee comes alive in Swinging London and kills a bunch of hippies. I saw the Original Sins open for Mudhoney, and the Butthole Surfers open for the World Saxophone Quartet. That one left a packed hall of bebop heads at Brooklyn Academy of Music baffled.

The Arto show twenty-eight years later was in a lecture hall at the Art Institute of Chicago. I showed up a half hour early at the front entrance of the museum and milled about on the steps. The doors were locked. I could see a guard inside but no other signs of life. Soon a few others joined me. None of us had ever been to a concert held after hours at the museum before. It almost felt like we'd all been hoodwinked, like we were the victims of a prank.

But a few minutes later the guard opened one of the doors and we filed into the darkened museum, then on into the hall. Eventually more people showed up but there were plenty of empty seats. Either the concert wasn't well publicized, or the non-standard setting put Arto's fans off.

The opener, Beauty Pill, played some sort of so-phisticated avant-garde rock. Less than a year later I have no memory of what they sounded like. This is not necessarily a knock on them. I forget a lot more than I remember. I *do* recall enjoying watching the frontwom-an swaying back and forth in her elegant black garb while manipulating some electronic contraption on a tall narrow music stand. I also know they liked my sketch enough to post it on Instagram. That's how I learned that their founder and leader was too ill to make it for the show in Chicago and that the elegant woman in black was filling in up front.

Arto played a weirdly schizo set, alternating between softly lilting Tropicalia and shards of atonal guitar riffs. He danced about like one of those loose-limbed *Dia de los Muertos* skeletons. Had he played any of the pretty Brazilian numbers back at the Knitting Factory in 1989, I wouldn't have gotten it at all. But now the duality or contrast in styles made some sense to me. Even the most out-there types need a breather now and again.

It being a concert at a world-famous museum, the whole event felt incredibly cultivated. Maybe a little too much so. If the Knitting Factory was too cool, the Art Institute was too square. Maybe when I see Arto twenty-eight years from now, the venue will be just right.

Nick Cave

The first time I saw Nick Cave was in the late 80s at a place called The Channel in Boston. I was seventeen and got in with my very fake ID with no problem. I'd bought it a few months earlier in a South End photo shop for 30 bucks. It got me into a bunch of shows at places like The Channel and Paradise, but was eventually taken away by a liquor store clerk who took one look at it and just started laughing before suggesting I go away before he called the cops.

I remember Cave wearing a 70s style three-piece suit and flinging himself around that little stage. (It was the same stage I watched Gibby Haynes of the Butthole Surfers douse a cymbal in lighter fluid, set it on fire, and bash away at it with a drumstick, making flames lick the low ceiling over and over. It was the way they ended their shows once the sex-change operation films projected over them had run out.)

All I really knew about Cave at that point was that he'd been in Wim Wenders' *Wings of Desire*. I'd only listened to a couple of his records even though he'd put out a half dozen by then.

I didn't see him again for ten years. At the Park West in Chicago in the late '90s it was a much more dignified affair than The Channel. The audience was seated supper-club style and Cave was doing a cabaret thing, playing the entire show from a grand piano. A bunch of people I know went to that show, including some I didn't yet know—like Shay, whom I'd be with for five years over a decade later.

Shay is the biggest Nick Cave fan I know. She did a bunch of very large, very sexual portraits of the man when she was in grad school. He's the kind of artist people have very personal relationships with. One time when I put him on at the bar, a young woman told me after the fifth or sixth number that it made her feel like she was at home in her own bedroom.

Cave is the only musician I've seen live in four different decades. Every time I go he's changed. It never feels like an oldies act, which by all rights it could be. He's certainly put in the time.

Plastic People of the Universe

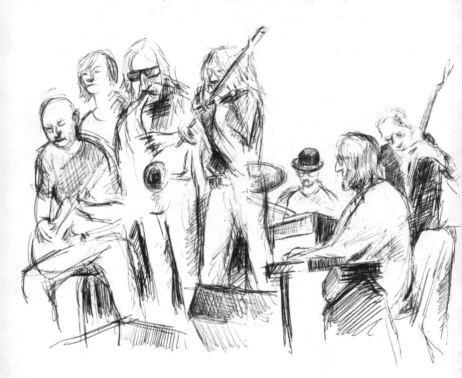

When the Soviet Union collapsed, a lot of musicians, writers, and artists emerged from hiding for the first time in decades, like tunnel dwellers squinting up at the sun. One of the more prominent of these were the Plastic People of the Universe, who are sometimes described as the Velvet Underground of Czechoslovakia. Some of them did time for playing their music; what Western band could claim that kind of commitment to their art?

Sometime in the late 80s, a few of the Plastic People came together in a group called Pulnoc (Czech for *Midnight*), toured the U.S., and stopped in Boston. I wore their t-shirt with the Pūlnočni Myš (Midnight Mouse) on it for years.

Another iteration of the band visited the Hideout Inn in Chicago in 2008. The Hideout is a bar in a little wooden house, situated off a desolate stretch of Elston Avenue which in 2018 is about to undergo a massive redevelopment. The bar has hosted an untold number of great musicians through the years and has served booze since Prohibition, but there's a very real possibility that it will be bulldozed into memories in the name of commerce.

The Plastic People came off as curmudgeonly Eastern European hippies, and the music they played undoubtedly sprang from the same soil as the Velvets. Forty years after their historical moment of political defiance, shows like this one were a sort of victory lap. How could they not celebrate outlasting one of the most brutal regimes in human history? Playing to a worshipful crowd in a friendly bar halfway across the world had to be pretty low stakes by comparison.

Mission of Burma

They called their reunion tour *Inexplicable* but I need-
ed no explanation (or much convincing) to be there. I
was too young to catch Mission of Burma the first time
around; I didn't even know of them until a year or two
after they called it quits in 1983. So there was no way I
was going to miss them this time.

I'm skeptical of old bands getting back together.
More often than not it's just a money grab coupled with
a sad attempt at recapturing real or imagined rearview
glory. The internet has more or less dissolved
any coherent
idea of history
where music is
concerned.
Because all re-
cordings and vi-
sual and written
documentation
exists in one
place, it some-
times seems
like it all came
from the same
time. Or, rather,
it's as if it's all
from now.

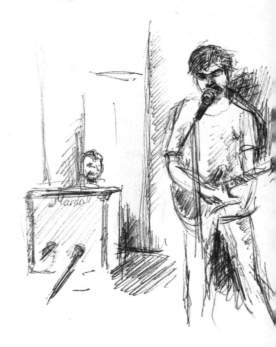

On the one hand, this is a beautiful thing. Music, after all, should be ageless and eternal and available to anyone at any time. But on the other, when the people who made said music are still alive, and they discover that there is a new audience which wants to experience what they missed the first time, it's difficult to resist attempting to recreate what they did in the past.

A friend calls these zombie bands. Entities like Riot Fest exist almost exclusively to give these groups new life. But more often than not, there's nothing fresh about a bunch of aged former cool kids trying to reproduce sparks on stage in the service of nostalgia and a belated payday.

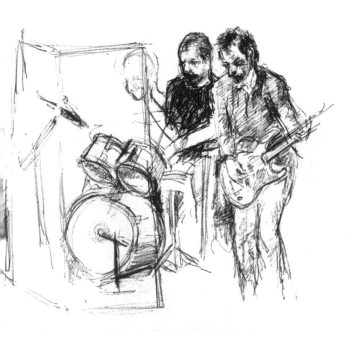

I have a theory that the music closest to one's heart is that which was made just a bit before one's time. For me that means Burma, the Minutemen, Husker Du, Wire, Television, et al. So when some remnant of bands from that era roll into town, I'm not immune from the urge to go see if there's any life left in them.

I've seen Burma play three times since they reformed. They never just play the hits or pander to nostalgists. They play their songs louder than most bands half their age and with no less urgency. They're not reliving anything—just living.

Minibeast

I got home on a hot summer night in 2018, took off my clothes, and was getting ready to turn on the TV when Elliot texted, "What time is Peter's band on tonight?" I didn't know what he was talking about, but a quick internet search yielded the Minibeast gig at the Hideout. Minibeast is Peter Prescott's solo act of the last few years. I got both their records but figured they'd never tour. It's harder and harder to do so these days unless you have a big audience. The soundscape-y thing Minibeast does is great but I doubt it's for the arenas.

I've loved every one of Prescott's bands. From the Volcano Suns in the 80s, to Kustomized and the Peer Group in the 90s, and the reformed Mission of Burma and this new thing in the last couple decades. So I put my clothes back on and pedaled across town to the Hideout so I wouldn't miss Minibeast.

I walked in sweaty and panting and ran into Peter a few minutes later. "I had a feeling you'd be here," he said. The room was practically empty, except for an oblivious couple on a very loud date and four or five people here for the music. Watching Prescott on stage took me back. Over thirty years of going to see this guy and it made me happy every time. "I'm sixty years old... way past my sell-by date!" he told me.

Hardly. I would've been mad to have missed him. When Elliot show-ed up, I thanked him over and over for the heads-up.

Shellac

I used to hate Shellac. I'd go see them and admire their artisanally-crafted amplifiers and guitars and be impressed by the precision of the herky-jerky stop-start anti-melodies for ten or twenty minutes, then I'd start to get frustrated and feel like they were just fucking with us. These three guys have played, produced, and otherwise had a hand in so many records that it wouldn't surprise me if this band was just a thing they did to amuse themselves. It doesn't help that so many of Steve Albini's lyrics read like sarcastic comedy rants.

But when *Dude Incredible* came out in 2014, Shellac finally clicked for me. The humor and obvious technical facility were still there, and it didn't come off as empty wankery anymore.

When something rejected for years starts one day to make sense, it's as precious a gift as a listener could hope for. An invisible switch is thrown and your view is turned topsy-turvy. There's no way to argue or will a moment like that into being. It's a matter of being open enough to let a thing work on you even if you didn't get it in the past.

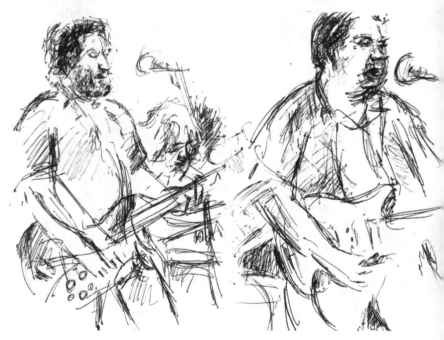

The thing with Shellac is I've been trying to like them almost as long as they've been around. Bob Weston was in Volcano Suns back in Boston—one of my favorite bands ever— and even has a couple of my drawings hanging in his house.

Weston also plays in a great band with Chris Brokaw called the Martha's Vineyard Ferries. Albini has been involved with countless records I've loved. I was once invited to a barbecue at Weston's house and Albini was there. But I was too weirded out by the idea of sharing grilled meat with the guy from Big Black to say a word to the man.

Shellac once considered using my taxi for their transport needs. I was at the top of the cab line outside the international terminal; they were trying to get home from O'Hare after returning from a European tour, and didn't want to hire a limo. But the Scion turned out not to have enough trunk space to fit their gear, so I ended up taking their opener, Helen Money, instead.

A woman and her cello have room to spread out in a Scion.

The Middle East

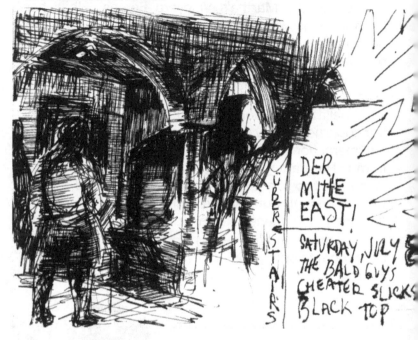

The Middle East in Central Square, Cambridge is one of the great rock clubs in Boston. It started out as the back room of a restaurant which served average falafels and kebabs, its worn and many-times-repainted Orientalist doorways and sconces evoking a seedy theme-restaurant version of exoticism.

I've forgotten most of the shows I saw there from the late 80s up to the last few years. It was the first place I saw Mick Collins play, when he came through town with Blacktop in the mid-90s. I saw the Jon Spencer Blues Explosion pack the Middle East Downstairs,

in the venue's tunnel-like basement, which was once a bowling alley. I was also there when New York no-wave legend James Chance and his band the Contortions played to a couple dozen of us. Chance was so depressed by the empty room that he barely played half an hour. I saw bands which played there almost monthly: Come, Kustomized, Moving Targets, Cheater Slicks, and others.

My friends, Dan and Adam, performed at the Middle East's third, and smallest, stage—the Bakery—several times. After I moved to Chicago, I'd occasionally ask friends in bands where they'd be playing on tour and, invariably, if there was a Boston stop, it was at the Middle East.

Unlike shuttered spots like the Rat and t.t. the bear's, the Middle East is still going. I try to stop in every time I'm in town.

Evan Dando

I was in Boston visiting my parents in the summer of 2015. Looking at music listings for something to do one night, I discovered that t.t. the bear's was closing that week and bringing back a bunch of old bands to see the bar into the hereafter. There were three or four nights of shows. I picked the one with Thalia Zedek and Chris Brokaw because their band, Come, is one of my favorites, and I'd seen them at t.t.'s more than once back in the 90s.

There was a line hugging the building down Brookline Street to the corner when I arrived. I didn't know anyone waiting, which is no surprise since I'd been gone from Boston almost twenty years.

One of the first times I went to t.t.'s was in 1988. Jane's Addiction was playing. I'd seen them open for Iggy Pop earlier that year and they were about to get very big. The tiny room was jammed and Perry Farrell had a full cast on his leg. I got some grief at school for wearing their t-shirt with the twin naked mannequins. I lost interest in the band soon after; I wasn't about to follow them into the arenas. Most bands I saw at t.t.'s were a lot smaller and would never become as big as Jane's.

I never saw the Lemonheads but I wore out my cassette of *Hate Your Friends* in high school. In the early 90s, driving cab through Kenmore Square, my passenger, an older distinguished business type, pointed toward the Rat and remarked that his son's band had played there. I asked what the band was called and he answered *The Lemonheads*. Without a second thought, I blurted out that all their records after *Hate Your Friends* sucked. I think he politely pretended to agree with his twenty-something cabbie/musicologist, but looking back I can't believe he didn't slap me upside the head. He was Evan Dando's dad.

t.t.'s opened its doors and we swarmed in. I hadn't been inside in a good decade but it looked much as I remembered it: an oblong two-sided bar at the center of the main room with some tables against one wall and a smaller room with a stage to the right of the entrance. I bought a t.t.'s t-shirt with the logo and bear paw prints and went over to the music room.

A half dozen acts took the stage that night. Evan Dando was one of them, though I didn't recognize him until he started singing. He banged out a few songs on his acoustic and left. He didn't look well. He was nearly as big as Jane's Addiction once upon a time, but those days were far behind him. I wondered how many times the Lemonheads had played t.t.'s back in the day. The club would be no more by the end of that week. The Rat, where they'd definitely played (according to Dando's dad) had been gone for years.

All that will be left soon are the recollections of those who'd been to these places. Memories which mutate and morph to suit those who summon them.

But Dando is probably on a stage somewhere right now covering "My Name is Luca" or "Mrs. Robinson," or one of his many originals.

Thalia Zedek

The only time I tear out pages from my sketchbook is to throw out failed drawings I don't want to see again. But when Thalia Zedek asked to buy one I made of her band, I didn't think twice about bringing out the X-acto knife.

I've loved Zedek's bands since back in the late 80s when she was in Live Skull, but it was her 90s Boston band, Come, which got me the hardest. I saw them at t.t. the bear's and the Middle East in my first years driving a cab. Taking a couple hours off to see them went a long way to saving my sanity during that time.

I got to know her bandmate, Chris Brokaw, later, when I moved back to Chicago, but had never spoken a word to Zedek. I'm not one for small talk, and it's not in my nature to walk up and introduce myself.

But now that she was buying a drawing from me, I felt like I had an in. So when she came back through town on her next tour, I walked right up to her at the Empty Bottle. I handed her the sketch she'd PayPaled me for and we had a nice chat. We talked about Boston and about common acquaintances and about bands. It's a great honor when somebody whose work you've loved for decades thinks enough of your work to pay you for it.

It probably helped my comfort level that we met at the Bottle. Situated on Western Avenue, on the outskirts

of Ukrainian Village, this is the club I've seen and drawn more bands in than any other. In 2000, I worked at the restaurant next door and would get into shows for free. I wandered in one night and listened to some pale guy trying to sing like Robert Plant. I stayed a few songs and left unimpressed. It was the White Stripes and they were on the cover of Rolling Stone within a year or two. Most bands I see there never make it that big, and I never know which ones will get traction and which ones will disappear without a trace.

E

I went to high school with Jason Sanford. Then we worked at the Coolidge Corner Theatre together. I remember Performance Art Night at his loft in Jamaica Plain and the scrap iron guitars he started making which turned into his band, Neptune. I had a dumb argument with him once about whether or not Madonna was any good. I was con; he was pro, out of some contrarian art-school reasoning. Or so I thought at the time.

On trips back to Boston I'd see Jason at a gig or some coffee shop. He's made a life for himself in Cambridge, working at a bike shop, playing music, and making art. He has a kid and a house now.

When I heard he was playing in a new band with Thalia Zedek I was really psyched to hear it. Their record

came out on the great Chicago label Thrill Jockey and they played at the Bottle a few days later.

The music they make has elements of what Zedek and Sanford have done in their other bands but they're onto something new. They're a trio with no bass player but their two guitars sound so different from one another that you don't notice at first. Plus, Sanford's welded metal instrument is more like a quick conceptual sketch of a guitar than a fully fleshed-out piece.

"Candidate" is one of the best songs about the political situation in 2016-17 America that I've heard. My long history with Sanford only added to how much I dug what they were doing on that winter night at the Bottle.

Chris Brokaw

When Chris Brokaw played solo acoustic at the Bottle in the spring of 2004, I was about to get divorced. *Eternal Sunshine of the Spotless Mind* had just come out around that time, but I couldn't bear to see it because it was about a woman erasing a man from her life. I was living it. Being disappeared. So when Brokaw sang

Now I see that we're coming to the end of the affair
I've got one final favor to ask of you my dear:
Can we pretend...that it was you on the receiving end
And tell our friends that it was my idea

he was giving me a way to cope. A way to spin my situation into manageable shape.

In the 90s in Boston, when I was first driving a cab, Brokaw's band, Come, helped me get through the isolation of my 20s in a city I loathed. Parking my Checker in Central Square and listening to them for an hour at the Middle East made the rest of my shift bearable.

But back then I would have never thought that coming up to somebody in a band and talking to them as if they were just a person was a thing one could do. At the Bottle in 2004, emotionally wrecked, I wasn't going to stand on ceremony. I went up to him after his set and told him what his song meant to me. I think he probably took a step or two back, but, to his credit, he was gracious.

Since then, we've kept in touch, sometimes writing back and forth about this or that. On a recent trip to Monhegan Island in Maine, I saw his name listed on a coffee shop's calendar of upcoming events. It made me feel closer to home.

Kent Jolly

I transferred to the School of the Art Institute of Chicago from Parsons School of Design in New York in the middle of my freshman year in January of 1990. I didn't know anyone or anything about Chicago, so that first semester I lived in a dorm at Roosevelt University,

because SAIC had no student housing back then.

Kent Jolly was always in his dorm room at the Herman Crown Center picking out tunes on his guitar and looking up hoping I'd guess what he was playing. This game could go on for hours. This is how art kids fill the time between classes.

We went to see the Cramps at Cabaret Metro and he took pictures right up against the stage with a throwaway camera. I still have those prints of Lux Interior sweating in his pumps and Ivy Rorschach glowering menacingly in a glittery dress behind her red hollow-body guitar. Kent always wanted to be up there too.

He had a band for awhile called the Gerunds, but complained that everybody mispronounced it *gheR-UNDS* and that nobody understood what the name meant. We lost touch for a couple decades after graduation in 1993.

I googled his name one day and found out he composed music for video games in the Bay Area. I dropped him a line. We had lunch when I was in Berkeley on a book tour. He brought his teenage daughter to the reading. Middle age brings with it a succession of such disorienting reunions. It's good to check in with old friends but bittersweet too because after catching up there's often not much more to say. Doing so would risk living in the past, which doesn't look good on anyone.

Still at it

Dexter Romweber

The first time I saw Dexter Romweber play guitar was in the Flat Duo Jets in 1990, opening for the Cramps at Cabaret Metro. I went to that show with Kent. He took photos of the headliners but didn't take any of the Flat Duo Jets, and I wasn't taking a sketchbook to shows yet, but Romweber left enough of an impression that I still usually try to catch him when he comes to town.

When he played the Hideout in October of 2016, he was up against a Cubs World Series game, but still, a city of several million could barely muster an audience of twenty for one of the true originals of rock music. The man's always seemed tormented, but that night he

looked on the verge of tears. It hurts to keep banging your head against a wall. Still, what else is there to do?

There weren't many people inside. Game 3 was on the TV and aside from places which had TVs, Chicago was a ghost town. I sat at the bar and ordered a drink and watched the game. Next to me was a tall guy in a newsboy cap, flannel, and arm tattoos. He had to be Dex's opening act. Sure enough, a few minutes later he got up and wandered back to the music room to set up. He went by One Trip Little and he played a bunch of drinking, fighting, praying, and wandering tunes. My favorite was a cover of Woody Guthrie's "Hard, Ain't it Hard," a song I knew best done by my friends, the Country Melvins, about twenty years back.

At the merch table after his set, I went up to Little and showed him the sketch. He liked it enough to take a cellphone pic. I told him I was sorry it was such a

sparse crowd and pointed back at the TV in lieu of an excuse. He seemed to take it in stride, or at least pretended to. Dex wasn't on stage yet so I went back to watching the game.

There was still no score and it was getting late. I looked outside and saw Dex sitting on the steps with his head in his hands.

He didn't have a drummer with him like he usually does. Just his old Silvertone guitar and cheap oversized shades which Jackie Onassis might've worn if she shopped at Walgreen's. The great thing about seeing Dex is you don't ever know what he'll play. A Link Wray instrumental will follow a crooner ballad, then a show tune, and finish with a piece of classical music. He has an encyclopedic knowledge of song. Even though there were only about twenty of us listening, we tried to make enough noise in between numbers to make him know he was appreciated.

In all the years I've been going to see him, Dex has never been much for acknowledging the audience, but this night he did something I'd never seen him do. As his set was winding down he suddenly put the guitar down and took the mic from the stand with a trembling hand and started talking. He said he was weary and didn't know if it was all worth it. People shouted encouragement but he waved them off as if to say, "Thanks, but the problem's bigger than you know." Then he told a story about being bullied by a big black kid in school and how it scarred him enough that he was still going to therapy to fight the racist thoughts it inspired. Then he went back to playing guitar. A few minutes later he stopped again and told a story about he and his buddy getting in trouble in high school for mooning a bunch of elementary school kids. He played one more song, then said goodnight and disappeared out the back door.

At the merch table One Trip was selling records and I bought Dex's new one. He asked whether I'd sketched Dex and I showed him what I'd done. "You should show Dex!" he said, and I nodded, but I knew I wouldn't.

Marc Orleans

In 1991, Marc Orleans was often covered in oil paint, skulking furiously around Room 302 in the Columbus building at SAIC. Room 302 was where the figure painting classes were held—a large space littered with easels, palettes, canvases, chairs, and endless rags soaked in paint and paint thinners of various kinds.

Marc was a senior and about to leave when I was getting there. With his red hair, big nose, and thick glass-

Vincent Van Gogh. But angrier. He was always frustrated with his painting and at war with our teacher, Dan Gustin.

Room 302 would be a battleground for me as well but when I first saw Marc I was still on the sidelines. His crowd were our forerunners but I don't think I ever uttered a word to the guy or to any of his friends. Painters can be intimidating just by virtue of their inarticulateness. One of the attractions of the canvas to a certain type of person is their inability to relate to others through words. Rage at the world can be expressed in paint better than any other way I know. There was no way of talking to Marc at that time from where I stood.

I ran into him in Boston after moving back there in 1993 upon graduation from SAIC. He remembered me from Chicago, which surprised the hell out of me. He told me he'd lost his mind over painting and had to give it up. He was playing music now.

I tried to go see him every chance I could. He was always happy to see me but also sheepishly apologetic about abandoning painting, as if I were painting's representative and seeing me reminded him of how he'd let us down. He played in a succession of different bands: Spore, Juneau, then Sunburned Hand of the Man. Each of these explored noise in different ways but the sounds became more acoustic and rustic as he went. We lost touch when he moved to New York.

I saw him playing pedal steel at the Empty Bottle in 2011 with a freak folk fellow whose name I don't recall. We caught up a little. He'd been busking in the subways in NYC and getting into old-time country music, studying banjo and pedal steel hard.

He was just as intense about it as he'd been about painting.

Wendy Clinard

I never learned how to dance. Watching others do it, especially people who really know how, is like hearing a good story—you're moving even as you stand still. It's rarely a straight narrative but the combination of gesture and sound can take you to places far from where you were when the dance began.

Over the past few years I've worked with my old art-school classmate Wendy Clinard on various projects. It's always a pleasure and a challenge to collaborate with her. She's got a unique mind and her own idiosyncratic way of communicating. Though the jumping-off point of her choreography is usually flamenco, she takes it to far-flung places.

One of Wendy's dance studios was in a storefront on Halsted Street in Pilsen. She's been based in the neighborhood over twenty years but when she was in that storefront passersby could watch as she put her students through their paces.

I sketched during some of their sessions and had a show of some of the better drawings on the wall opposite the mirror in which the dancers watch themselves.

Drawing dancers is difficult for obvious reasons—they don't tend to stand still much. But anyone who's gone to a few figure-drawing classes will know that it

is virtually impossible to hold a human body still. Figure drawing is a constant renegotiation of limbs and lighting, as even the greatest model will fail to make herself a statue. After a time some artists actually begin to look forward to having to deal with these readjustments. A good figure drawing—or any kind of drawing for that matter—is not a record of a single moment but a collection of many moments presented all at once.

Sitting in on Wendy's classes is a chance to grab at moments which disappear as quickly as they coalesce. But if you spend a few hours watching them twirl and

stomp and spin their limbs, the beats they tap out with their metal-tipped shoes can't help but invade the marks you make. All these drawings can do is catch a glimpse here and there, but hopefully the better ones will make a viewer want to go see and hear the actual thing.

Country Melvins

I was set up to hate Mike before I met him. Nancy had started dating him a few weeks before and complained about him all the time. She was my manager in the fine arts department at Pearl Art & Craft. After work, we'd go to Tuman's Alcohol Abuse Center so I could listen to her bitch about him.

I saw the Country Melvins soon after that. It was probably at Pop's on Chicago, a ramshackle country bar run by a hillbilly named Tommy. It was the band's de facto headquarters. Mike's low voice rang out over Bud's banjo and Jessica's violin.

The songs were slow, spare rearrangements of country jigs and murder ballads. I didn't know what to make of it. Mike came up afterwards and it turned out he had heard of me like I'd heard of him. He wasn't supposed to like me either. We became friends anyway.

The Country Melvins grew on me too. Enough so that when Mike asked for some art for their third CD, I was happy to oblige. I came up with a riff on Manet's *Execution of Emperor Maximilian*, but in mine, the band's instruments faced the firing squad. Mike sat at Jinx Coffee on Division Street for weeks trying to animate my drawings for the band's website. Like so many projects from that time, it was eventually cast aside and abandoned.

The band broke up soon after they self-released that CD. Mike and Jessica left town. Bud stuck around a few years but eventually moved away to New Mexico with a different violin-playing Jessica. But a few of their songs have stayed with me. "Johnny Mountain" and "Whiskey River" get me every time they pop up on my iPod and their unrecognizable cover of Kenny Rogers' "The Gambler" will forever haunt the dark recesses of my memory.

Wet Wallet

I met Keith Herzik in 1997 when we both worked at Pearl Art & Craft on the corner of Chicago and Franklin. That store is long gone, replaced by one of those Walmart neighborhood stores for a time, but now sitting vacant for years.

In the late 90s Keith fronted a band called 36 Invisibles which was mostly schizo noise and chaotic riffing. They played at places like Pop's on Chicago—a bar which has not only been closed over fifteen years, but whose building has been demolished for almost as long.

There's no place in the Ukrainian Village of 2018 for a place like Pop's.

Keith moved on to an outfit called Galactic Inmate for a time, but now plays guitar in Wet Wallet with his wife, Gina, who was in the punk rock *a capella* group The Blue Ribbon Glee Club for many a moon.

What Keith has done all along is make art. His Day-Glo animals have adorned rock posters all over Chicago. I have no idea how he chooses the colors for his silkscreens but I'm in awe of what he comes up with. They shouldn't work, but they do.

Punk Rock and Donuts happens at the Bridgeport branch of the Chicago Public Library on Saturday afternoons every few months. Jackalope Coffee down Halsted provides the coffee and donuts. As for the punk, librarian Jeremy Kitchen invites two or three bands to play in the back room.

Keith and I are both still doing our thing after twenty years. It feels like a full-circle experience, although at least in his case, the audience has changed; when I caught his set at the library, he played shirtless, to an audience which included a fair number of parents and toddlers. It's the only truly all-ages show I've ever been to.

Groundspeed

I met George Goehl on a basketball court off Division Street sometime in the late 90s. We were part of a weekly Saturday morning game of hung-over, out-of-shape art and music guys, all edging toward thirty or already fallen over that precipice. Most were at career crossroads, realizing that the dream of the band/art career/ whatever creative pursuit would have to be given up to make a living/raise a family/become a useful member of society.

The games could get rough, with thrown elbows, skinned knees, and the occasional bloody nose. I hadn't played much since high school ten years earlier and had certainly not gained any finesse in my game. But now I was totally unafraid of contact the way I'd been in my teenage years. I also had between-game cigarette breaks to look forward to.

George was a far more skilled player. I also found out he wasn't half bad on the banjo. His bluegrass/country combo Groundspeed also featured Lawrence Peters on washboard and vocals. Lawrence would be a mainstay of countless bands and as a bartender at the Hideout, where so many of the drawings in this book were made.

Groundspeed was a casualty of the above-mentioned growing up business. George made a great documentary film about bluegrass pioneer Jimmy Martin, and moved on to a career in labor organizing. I get an occasional email from him about getting a drink, but it rarely happens.

His band did a one-off reunion on the porch in front of the Hideout in 2015. Lawrence might've gone inside and served drinks inside afterward, while I walked to North Avenue to catch the bus, on to draw or write something, no doubt. George probably went back to being a grownup. I wonder what strapping on the banjo felt like for him. Was it a reminder of a thing he missed? Or confirmation that he was right to have walked away?

Bill MacKay

I happened on Bill MacKay playing guitar on the patio of Letizia's Bakery on Division Street, kitty-corner to the ugliest hospital in Chicago, in the late-90s. I don't remember the tunes he played that afternoon but do recall thinking he was way too good to just be a soundtrack to folks nursing muffins and cappuccinos.

In the 80s "Saturday Night Live" had a bandleader named G.E. Smith. He slicked back his grey hair and wore retro duds. The guitars he played looked vintage and were undoubtedly pricey. He knew every hot lick in the book, as well as the corresponding facial ex- pression meant to underline the deep feelings behind every last riff.

The trouble was that not a note he played ever rang true.
Anytime he shut his eyes and leaned back, as if under
his own spell, I'd wish a piano would land on him so that
just for once the emotion on that mug were real.

Bill MacKay is the opposite of G.E. Smith. He un-
derplays when a lesser player can't resist wailing away.
Over the many years I've gone to see him, I've heard him
play jazz, pop, country, and everything in between. But
there's always a gentle, searching quality, a wistfulness
to everything he does. I've sketched him playing guitar

more than anyone else because I always want to witness where he'll go next.

In the past couple years, his star seems to have finally risen. He's out of town, sometimes overseas half the time I text him to meet up for coffee. I miss his company but I'm glad he's finally getting some overdue recognition. It couldn't have happened to a nicer or more deserving guy—he's come a long way from entertaining latte sippers with a brutalist hospital for a backdrop.

Vernon Tonges

I ran into Vernon at Star Lounge around 2013 after not seeing much of him over the previous decade. His laptop perched on his chest, right up to his face, wedged in place by his voluminous gut. I'd spot him around Ukrainian Village and Humboldt Park regularly when I lived nearby. He and his wife were brunch mainstays at Bite the year I worked there. A big, fumbling character who'd squint, glasses on his forehead, while scanning the menu intently to decide what to eat.

A bunch of my music friends used talk about his singing like you would about a secret legend. I didn't witness it myself until sometime after running into him in 2013. It turned out he'd made the coffee shop his home away from home and decided to sing some tunes there one afternoon.

He belted out his funny, weird story-songs in a gravelly no-holds-barred wail. Afterwards I asked if I could buy a CD. Vernon was surprised and seemed flattered. He refused to take much money but promised to mail me something soon.

A week or two later a CD of the collected songs of Vernon Tonges and the Inepti was in my mailbox. Vernon included a thank you written on the back of a thickly-painted postcard of a happy skeleton dancing around in a night of stars.

I hope Vernon is singing his songs at the top of his lungs some place as you read this.

Fred Anderson

I got a Fred Anderson record when I was in art school in the early 90s. He's a smiling middle-aged man in front of the Chicago skyline on the cover. I didn't get to hear him play till I moved back to town at the end of that decade. His tone was deep but understated and had a drive that went on and on.

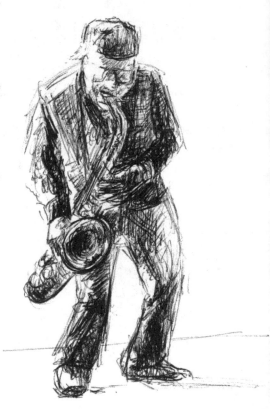

Later I re-member him at the door of the bar he owned, the Velvet Lounge, greeting people, making sure everthing was going smoothly.

The Velvet Lounge is still on Cermak, in name at least, but Fred's been gone since 2010.

Mekons

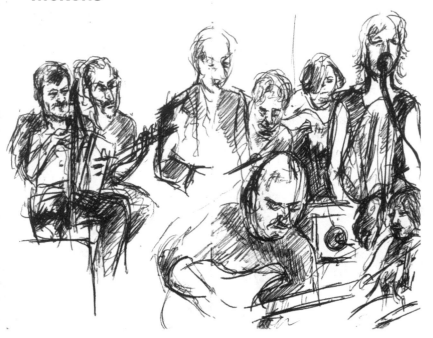

The Mekons were auctioning off dubbed cassettes of songs one at a time right after playing them at Fitzgerald's in Berwyn in 2004. I had the winning bid for "I Work All Week" then made a pest of myself telling Sally Tims what the song meant to me, when all the poor woman wanted to do was take my money and get on with her night.

A few weeks earlier my wife had left me and I had no business being out in public. But the Mekons are just the right band for someone to make an ass of yourself in front of.

Chicago is stupid lucky to have been home to this band these past decades. There should be public sculptures of them around town; instead they play little spots like the Hideout, known only to a fortunate few.

I've been introduced to Jon Langford dozens of times and he never has the faintest idea of who I am, but I'll never ever hold it against him. Sally Tims has always been gracious and friendly, luckily showing no memory of my outburst at Fitzgerald's.

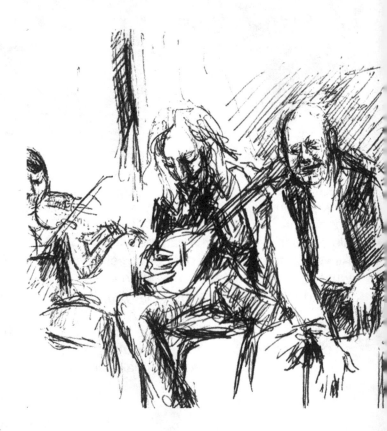

The Mekons could be excused if they became a nostalgia act like almost all their late-70s cohort. But maybe because they never "made it" the fire which drives them has never gone out. They stubbornly persist in the face of a culture which values salable commodity rather than artistic expression. They're like a species that was supposed to be extinct but keeps reappearing unexpectedly, a prehistoric fish from the ocean depths that shows up in a fisherman's net.

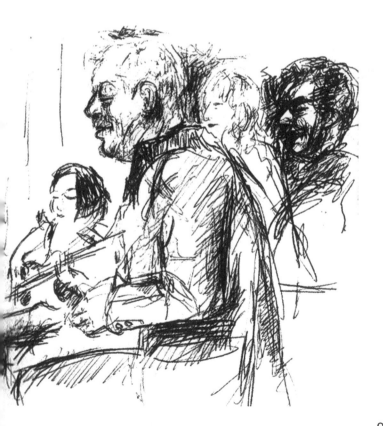

Condo Fucks

I discovered Yo La Tengo in the late 80s when I was still in high school. They were sort of a bridge between a lot of great 60s bands I was too young to have caught and the noisy, abrasive NYC bands of that time. They liked pretty melodies and guitar feedback in equal measure.

I wore out my CD of *President Yo La Tengo/New Wave Hot Dogs*.

Their covers record *Fakebook* introduced me to a lot of songs I'd never heard of, while also acknowledging familiar weirdos like Daniel Johnston.

Their deep appreciation of their predecessors was all over their own tunes. They were sort of the best cover band ever, even while playing their own originals.

They lost me during a Lounge Ax show in the early 90s. The last couple times I'd seen them, they'd had an organ onstage. Ira would tape down a key with duct tape and let it drone while wailing away on his guitar. It was a texture, a layer of background sound added to the mix. But at Lounge Ax that organ became the dominant sound. The new songs sounded like lullabies Ira and Georgia where whispering to each other. It was touching for a song or two, but got tedious after about ten minutes.

Their 1993 record *Painful* was the last one of theirs I bought. Most of their fans love that one and the ones which came after, but my favorite parts of their sound were now buried deep behind a monotonously blissed-out organ drone. Maybe that's not fair—and granted, I didn't listen to every single thing they put out in the last twenty-five years—but who says love has to be fair?

Art isn't sports. There has never been a metric devised to prove definitively one song is better than another. Attachment to a band, especially one going back some years, is probably even more difficult to quantify. That's why arguments between fans about their favorite bands are so pointless. There's so much that goes into loving a band that is tied to one's own biography, the circumstances of discovery, and a thousand other factors, none of which can be lined up next to someone else's in any way which would produce a "winner".

Whether justified or not, I gave up on Yo La Tengo around 1993 and didn't see them again until 2010 when they appeared at the Hideout disguised as the Condo Fucks. They were there to open for their friends, Eleventh Dream Day. I went to the show because Janet from that band put me on the list. Whenever a popular band like Yo La Tengo appears at a tiny spot like the Hideout, tickets go fast, so I was lucky to be there.

To my great relief there was no organ onstage. The band ripped through a bunch of punk and garage covers, short and sweet, then they were gone. They were a lot like the band I used to love back in high school.

They came back in 2017 to play the Hideout Block Party on a bill—put together by Dream Day's Rick Rizzo—of bands with members turning sixty. (He called them Sputnik Babies, after 1957's most famous event.)

It's weird that Yo La Tengo has to become the Condo Fucks for me to love them again. Does this mean that the early years of the band were just an immature phase they grew out of, and will only revisit now as an alter ego? Few bands put out more than an album or two that one will be truly attached to over time. The Condo Fucks don't make me want to revisit all those Yo La Tengo records I missed, but I was happy both times I watched them bash through a bunch of other people's tunes. They owe me nothing, and I'll always respect them for going wherever their muse points them, whether I want to follow or not.

Eleventh Dream Day

When Rick Rizzo joined Yo La Tengo onstage at Lounge Ax in the early 90s, it was the first time I'd heard him play guitar. I rarely missed a chance after that. Had I grown up in Chicago, I'd have heard of Eleventh Dream Day a lot earlier.

The early 90s was the end of Dream Day's run for the brass ring. They were on a major label for a couple records, swept up in the hysteria of the grunge rock marketing frenzy. They probably had some songs on the radio, but by that time I'd stopped listening to music that way, so I don't know for sure. I was getting all my music by going to shows or visiting little record stores or hear-

ing tips from friends; my painting classmate, Frank, turned me on to them.

When I moved back to Chicago from Boston for good in 1997, Dream Day not only became part of my regular soundtrack but started making appearances in my day-to-day life. Rick bartended at the Rainbo Club, where I'd usually be too shy to talk to him. (Or John Haggerty from Naked Raygun, who also worked there.)

I'd see Doug at Leo's Lunchroom and at countless shows. Janet started dating a regular at a restaurant I worked at. Later she'd commission a painting of their home for her by-then-husband's birthday. All the while, every few years Dream Day would put out a new record, play a few shows, then disappear again.

After twenty-five years of screaming solos, guy-girl vocals, and biting between-song banter, I still look forward to every time Dream Day plays. When Rick programmed the Sputnik Baby show at the Hideout Block Party in 2017, all the bands put the lie to the idea that rock music is only for the young. They played music about their actual age, rather than just looking wistfully back at the glory days.

Longevity is double-edged sword. Stick around and you risk repeating yourself, getting taken for granted, becoming a parody of your earlier self. Or you can keep changing, public be damned. No matter how sporadically Dream Day shows up, each time is a chance to reassess, to add to what's already been done, to grow.

Freakwater

For years I thought there was a conspiracy against my seeing Freakwater play live. Either the show would be sold out, or I'd be out of town, or they'd skip Chicago or they'd go on hiatus.

Catherine Irwin has to be one of the most nimble phrase-turners going—she's like the Flannery O'Conner of music. The simultaneous singing she does with Janet Bean is one of the most distinctive, raggedly beautiful sounds I know. It's not for everybody, though. I had an ex who asked me to turn Freakwater off once. "You think that's good?" she wondered, horrified. We didn't last much longer after that.

"Great Potential" has to be one of the best put-down songs ever, and "The Waitress Song" could be an anthem for anyone in the service industry. I learned recently that Irwin briefly worked at Leo's Lunchroom—a restaurant which played a formative role in my life—and it made me love that song all the more. Even when Freakwater does covers they make them sound like they wrote them. I had no idea that Janet Bean's *a capella* "You Make Me" was a Nick Lowe song. I knew "You've Never Been This Far Before" as a Conway Twitty number, but Irwin turns the creepy cradle-robbing lyric upside-down with her delivery.

In 2013 I finally got to see them. I was even there with a woman who sort of liked them. Or liked their between-song banter anyway. I've seen them three or four more times since, plus some solo Catherine Irwin shows for good measure.

I drew a second version of my 2013 sketch, put it in a thrift-store frame, and displayed it in a show of music-related art. When it didn't sell, I hung on to it for a time, then brought it with me to an Irwin gig and had a mutual friend give it to her. I never found out what she thought of it.

Brokeback

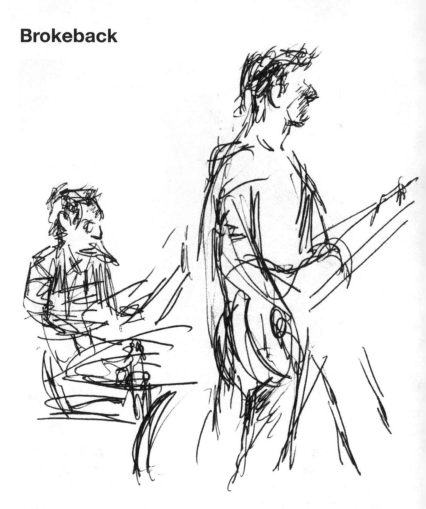

I went to see Brokeback play at the Bottle and had a nice conversation with Doug McCombs. I've drawn Doug dozens of times because he's played in so many great bands in Chicago but we've rarely talked until the last few years. My enduring memory of him is from

sometime in the late '90s at Leo's Lunchroom: the two of us the only customers in the place not even acknowledging one another's presence. There was never any hostility or anything like that—just two shy, taciturn guys keeping to themselves.

Horse's Ha/Nightingales

I go see any band Janet Bean's in. With Jim Elkington, she made thorny, meandering folk tunes as the Horse's Ha. They liked the drawing I made of them at the Beat Kitchen enough to consider using it to illustrate the Japanese issue of their debut CD. It never happened, but for a couple years the drawing would pop up in image searches, surrounded by Japanese characters.

They opened for a British band called the Nightingales the first time I saw them. I don't know if the Nightingales ever played the US before, but they've been together off and on since 1979. They split the difference between Gang of Four's rhythmic repetition and Mark E. Smith's harangue/talk/singing.

I liked them enough to buy the CD they were hawking that night but forgot about them for years. But every time they pop up as I scroll through my iPod, I listen to a few of their tunes and wonder why I don't do so all the time. As with many bands rooted in a time and place that's not my own, I don't always know what they're talking about, but they usually sound resignedly aggravated. Who can't identify with that?

The Cairo Gang

The Cairo Gang is Emmett Kelly and whichever friends are around to back him up. Emmett explained to me once why he named his band after a group of British undercover agents fighting the IRA in Ireland but I don't recall the story.

Whatever he calls it he's got a great knack for jangly 60s melodies. He's also always popped up backing others and always makes them sound better. I've gone to see bands who I never cared for until he played with them more than once.

Other times, like the night Baltimore band Arbouretum played Thrill Jockey Record's 15th Anniversary, seeing Emmett up onstage added a welcome wrinkle to an already great band.

Emmett split town a while ago. He's back in LA. I miss seeing him around Chicago. I'll put on a Cairo Gang record now and again and wonder where he's at. Probably on stage, making his bandmates sound better than they ever would without him.

JINX

Joan of Arc/Disappears/FACS

When Jinx Coffee opened on Division Street toward the end of 1997 it filled a vacuum. Urbus Orbis—the coffee shop which laid the groundwork for the demise of Wicker Park—was about to close. I had just moved back to town from Boston and Urbus was the first coffee shop I logged serious time in. It was the first true third place in my adult life but was gone before I could even make myself fully at home.

Jinx was staffed by a bunch of art and music kids— Tim Kinsella and Jonathan Van Herik among them. This was before the internet so I had no idea Tim had already been in bands for years. To me he was just the sullen coffee shop kid who played Scott Walker all the time.

His band, Joan of Arc, was made up of a revolving cast of friends who congregated at that shop.

I made illustrations for an Italian kid who worked at Jinx. He was going to use them for a 7" for his band, Audience of the End. He never did, but I have them in a drawer somewhere, just waiting for some punk band in need of a Georg Grosz-style drawing of cops beating on a guy in an abandoned lot littered with busted bottles and spent syringes.

After both Jonathan and Tim crossed the street, rounded the corner, and started bartending at the Rainbo Club, I didn't get to know them any better, but I was much more aware of the music they were making.

I don't think Brian Case ever worked at Jinx or the Rainbo but he was always around. When Jonathan and Brian started Disappears, sometime in the mid aughts, I was all in.

They had a hollow, empty house vibe which per-
sisted through a Spinal Tap's-worth of drummers. The
songs mutated from minor-key melodic to an increas-
ingly sparse, angular, abstract atmospheric sound by
the time the band itself disappeared. I loved every it-
eration. I made countless paintings with their spectral
sounds as a backdrop.

Then FACS rose out of Disappears' ashes and it was like like hitting a reset button. The lineup was three-quarters of the old band but it was a new thing.

Their first show was on an old-fashioned parquet basketball court inside the recently-refurbished Chicago Athletic Association Hotel on Michigan Avenue. They were opening for Joan of Arc.

All those art kids were now working in bespoke cocktail bars and trendy bistros and programming music at posh spots like this one.

Tim interviewed me for his short-lived blog the summer before my first book came out. We talked into his iPhone while sitting on a picnic bench in the Rainbo's backyard.

I was surprised reading that interview again recently how friendly and familiar we were with each other. We had probably had only a half dozen serious talks but had known one another for about fourteen years. It adds up without your noticing it.

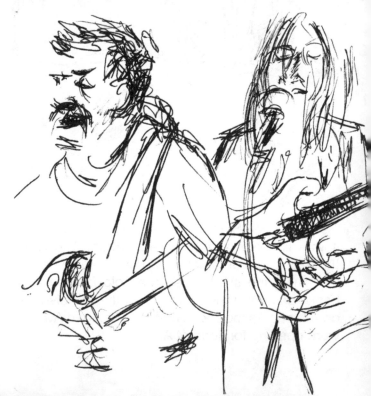

A couple years later he commissioned a double portrait of Charlie Chaplin and the Elephant Man for a Joan of Arc record cover. Then came portraits of the Dardenne brothers for the covers of a two-volume set of their film diaries to be released by the literary press he runs.

As isolated as I often feel, I have to admit that guys like Tim and Jonathan and Brian are part of whatever passes for my idea of a cohort or community. We don't spend much time together but when our paths cross there's a recognition and mutual respect for continuing to plow ahead.

Noel

I know Noel Kupersmith from the time he used to clean the Rainbo Club. He was usually there having a post-work beer when the bar opened at 4pm. Then he became a plumber.

A guitar player named Kevin Mc-Donough started Sound Plumbing and hired Noel as an apprentice. After that, every time I saw either of them they were covered in grease and grime. They worked on the pipes of all the bars and record stores where all their current and former band-mates worked. One time I even called Kevin to my house for a clogged drain.

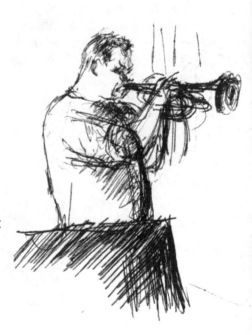

The fix was so simple he didn't even charge me.

I don't know if Noel still plays bass. I don't recall the date when I drew him at the Bottle playing with cornetist Rob Mazurek, and that may have been the only time I ever saw him play. Even so, every time I see him at the bar, in the back of my mind I know he has this other side. He's not just a guy who digs through basements; he's also a guy who plucks strings.

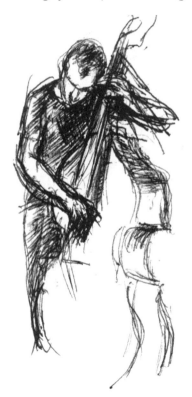

Sons of Maple

U.S. Maple

U.S. Maple was a scary band. They cut up rock music into jagged bits and pieces, then blowtorched the broken parts back into mongrel forms with the seams and sutures still showing.

They didn't look like anybody you could be friends with, either. (Although that may be my own projection, since I didn't really try to be friends with any of them until later.) I *did* wait on guitarist Todd Rittman at two different restaurants, and felt each time as if there were an impenetrable shield around the man. If body language were audible, his would've screamed *STAY AWAY*.

After U.S. Maple splintered, most of its members kept playing. I saw guitarist Mark Shippy play a beautiful acoustic set once at the Viaduct. That's the night I found out he was actually very approachable, despite the oft-menacing music he was involved in.

Drummer Pat Samson played for a time with my friend Bud in an outfit called Slow Planet. They played gentle, melodic pop: a polar opposite to U.S. Maple. I was invited to a barbecue at his house once and couldn't get over the disconnect between that domestic bliss and the stormy aggression of his old band.

Then Shippy and Samson showed up with Miracle Condition, which stretched out U.S. Maple's guitars into prog- or space-rock atmospheres. Instead of an assault, this was more of a slow burn, but you could still sense some menace just underneath the waves.

Rittman reappeared first with Rob Lowe—who I knew from Jinx Coffee—in a band called Singer, then as bandleader of D. Rider, later rechristened Dead Rider. I've still never said a word to the guy.

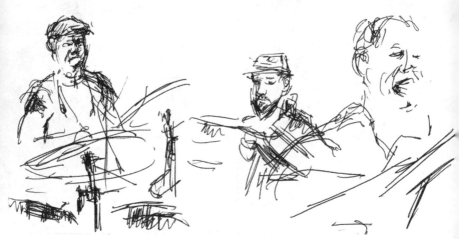

I've seen Shippy play with my good friend Bill MacKay, and on a couple records by his new duo Invisible Things. Each thing he and the other old Maples do pushes the language of their sounds further in different directions while still occasionally echoing where they came from.

I'll bet I've missed dozens of projects each has been involved in—they just don't stop.

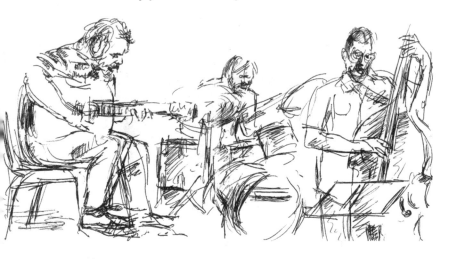

At the 2017 Chicago Jazz Festival, I was really digging what Tim Stine was doing with his trio. It reminded me of U.S. Maple. Then I realized that Stine's drummer, Adam Vida, was Maple's last drummer. The branches, roots, and tendrils of that weird old tree know no end.

Azita

Azita Youssefi used to come into the restaurant I worked at to bum cigarettes. She was always quitting. It took me some time to figure out that we'd been at art school the same years. SAIC was big enough that it was possible to never meet many of your classmates. Azita was doing out there stuff like locking herself in the display cases at the Rainbo Club as a performance piece; I was painting the figure from observation. We may as well have been on different planets.

But if you stick around a town a few years making art or music you eventually meet most of the other people doing the same. There aren't many who stay with it.

I saw Azita's band Bride of No No at the Bottle a few times. They dressed in matching white burkas and played noisy rock. Soon after that she switched gears, performing solo, singing and playing piano.

One late night in the winter of 2003, she came up to me at the Bottle and asked if I wanted to paint a cover for her record. It was due in a week. I painted the thing three times till I got it the way she wanted it. She knew exactly what she was looking for but needed somebody else's hand to bring it into being.

Her music has become progressively more melodic and tuneful, but there are still glimmers of her experimental noise rock beginnings. She did it backwards from how most people do it—she went from out there back toward the middle of the road, rather than the other way around.

She often disappears for a year or two and reemerges with a new set of songs. The record I did the cover for was heavily influenced by Steely Dan, so much so that she showed me their album covers to get a feel for what she was looking for. On the next one, her jumping-off point was Neil Young.

Mining others' art is a tried-and-true method to find one's own way forward. Azita's voice is in no danger of disappearing under anyone else's spell. I once heard her play Joe Jackson's "Breaking Us In Two" in a way which made me almost forget it wasn't hers.

Azita & Human Bell at AV-Aerie (2008)

The AV-Aerie was an artist's loft, but for a time a bunch of bands played there. In a room like that, everything seems temporary, provisional. There's no stage, nor even a designated place for people to sit or stand while listening.

Artist lofts have always been insane-making for me. These cavernous spaces with their conceptual semi-walled-off private sub-spaces (in lieu of actual rooms) make me anxious. The people who thrive in these environments are involved with what they consider big important art questions. Questions which call into doubt the very idea of what a living space should be. But after my own very brief such experiment, I ran screaming back to a conventional apartment, the layout of which permitted me to go on asking my own very important art questions.

That said, Human Bell filled that big room with their intricate, commingling guitars. I stopped wanting to leave or wondering where to stand once they began, and those thoughts stayed away until they finished.

Azita followed with a solo set on electric organ. I remember helping her carry that thing—or a part of it—to a gig once, and I didn't envy whoever was charged with lugging it up the flight of stairs that night.

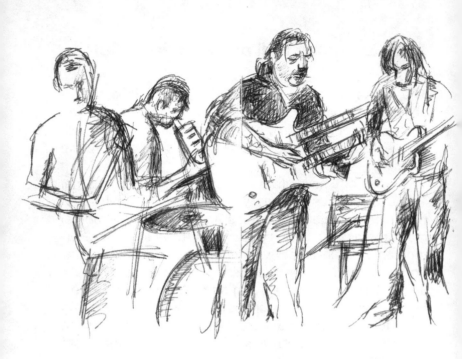

Watching Azita play is always an intense experince because you can see the effort of what she's doing on her face—a grimace one moment, inscrutable and remote the next. She played a beautiful Neil Young cover that night.

After the music ended I didn't stick around. Without sounds to fill it, the room reverted to its unformed state: all undefined potential. It's the same sense I have going to a party: a lot of conflicting, inchoate energy with no destination or direction. Leaving has always been my specialty at social occasions, so I found the stairs leading outside and into the night.

Lux

When Matt Lux asked me to write liner notes for his record, we met in Bridgeport. He parked right where the sorely-missed Lithuanian restaurant Healthy Food used to be. When he was just starting to play, older musicians would take him around town to discover all the special spots. He calls one of his tunes "Paw Paw" after a native fruit which has never gained widespread popularity because it doesn't travel and must be eaten within days of being picked. Lux passes on knowledge as it was passed on to him.

What do you call this music? I ask, and he just shrugs. This isn't because he doesn't know what he's doing or lacks the language to explain himself. Opposites attract him. There are horns, drums, and bass and non-bass guitars on this record but it isn't jazz. There are electronic blips, wheezes, and barely audible echoes filling the imaginary rooms these numbers conjure. There's even a human voice or two now and then.

"Space-folk," he offers, half-joking, I think. This from a guy who's come to couch his opinions with the caveat that he hates Sonny Rollins but loves Culture Club. He tells me that some of the titles of these tunes refer to Biggie Smalls, Colin Kaepernick, and Lester Young, among others. But I won't tell you which is which, because no one wants their work explained away by influences and inspirations. Besides, where one starts is rarely where one finishes, so identifying jumping-off points won't necessarily help you appreciate where it will end up. I didn't know any backstories the first couple

dozen times I listened to this record either.

The songs are sometimes loud, other times quiet, but they always move around in a ruminative sort of way. When they meander, they meander with purpose. Lux named his band the Communication Arts Quartet after a building at Walt Disney Elementary, which he attended as a child. I have to believe the old imagineer himself would be transported were he to hear the music made by this graduate of his namesake school.

While Lux's compositions don't bludgeon you with their messages, they aren't willfully obtuse, either. Communication's in the name for good reason. Lux isn't about making listeners suffer. Rather than trying to impress some self-appointed musicologist, he'd prefer to make something his mother would enjoy.

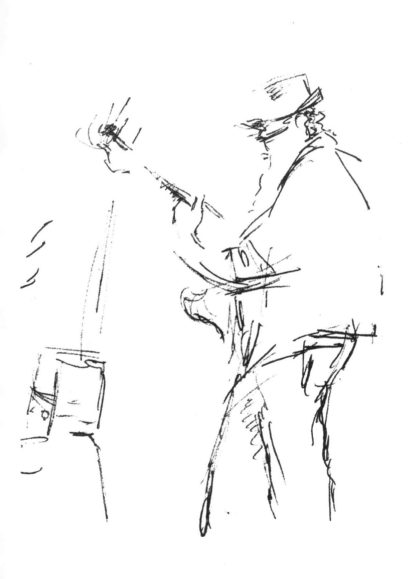

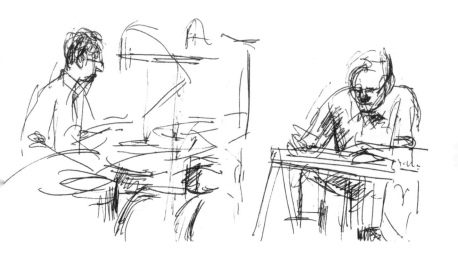

FRIENDS

Skyler Rowe

Skyler Rowe performed what he called "a tantrum" on his drum kit and various electronics upstairs at Myopic Books. Things like this can be precious or navel-gazing but by creating a lot of sounds in varying volumes and timbres, Skyler kept my attention and interest. He was also humble and gracious to his audience, the very presence of which seemed to surprise him—it can be hard to get anyone to come watch you do your thing.

I met Skyler when he started working at the Rainbo Club a few years back. Though he's nearly twenty years younger than me, we've become friends. He's always got a bunch of musical projects on his plate and has a young man's energy and enthusiasm, which I find refreshing and even occasionally infectious.

When he asked me to design the CD art for his Mute Duo with Sam Wagster, I jumped at the chance. I used a couple charcoal drawings of a junk-filled garage for the front and back covers and a sketch of the duo in action for the gatefold. I put another junk drawing on the disc itself and typed out all the text on my manual Smith-Corona.

Contributing art for friends' records is one the great joys of my life. It feels like completing a circle which starts with hearing their sounds, then drawing them playing live. I love playing my small part and helping them share what they've made with others. It makes me feel like I'm making some of the sounds without playing a note.

The Flat Five

The Flat Five kill me. I'm not normally a fan of harmony singing, of pop tunes, or of much on the sweeter side of the music rainbow, but they leave me a weepy mess every time I see them. I wouldn't be caught dead listening to any Beach Boys tune which isn't all theremin and sound effects, but I hum along happily when the Flat Five cover them.

They start with Bob Dorrough's "Without Rhyme or Reason" then do Trip Shakespeare's "Snow Days" a few songs later. Between those two tunes, I had a very hard time keeping my composure.

I can't put a finger on what gets me, but it's like Kryptonite; it's no use even trying to fake being a tough guy when there's tears running down your face. Luckily, I keep it together enough to finish my sketch. Sad ones followed happy ones, all delivered with impeccable timing and taste, giving the poor saps in the audience little chance to recover.

The Flat Five usually only play once a year due to the fact that everyone in the band has other commitments. Kelly Hogan, Nora O'Connor, Scott Ligon, K.C. McDonough, and Alex Hall could—and do—all front their own bands. Each have their moment in the spotlight, but the times that all are singing together are the ones that

really go beyond. It's a commonplace to say of a singer you like that you'd listen to them sing the phonebook, but in this case, I'd pay to hear them sing utility bills, scraps of paper off the sidewalk, or anything else they felt like. As to the topics they do pick—I'll just say it's quite a feat to make me pay attention to a song whose main gist is that flying kites is fun.

Neko Case

I've known Kelly Hogan a long time but don't get to see her as much as I'd like. So when she told me she had an afternoon free before a show at the Tivoli Theater, I took the Metra out to Downers Grove. Kelly was on tour with Neko Case and they were staying at a hotel nearby.

I don't know Neko well but we've met a few times. I gave her a ride to the airport in my cab once. We talked the most when I was on Twitter. She'd sometimes retweet something of mine which would temporarily get me a bunch of follows; they inevitably dropped off once they realized that I wasn't a famous person like her and there was no cultural capital to be gained by following me. Still, I found Neko funny and smart, so I enjoyed shooting the breeze with her, albeit in that artificial media setting.

I don't know her music very well either. My primary connection to it is that Kelly's involved. Still, I rarely refuse an invitation to see a band play, so I was looking

forward to the show.

I got off the train and Kelly pulled up a few minutes later and we drove to the hotel for lunch with Neko. We met her in the lobby cafe. I hadn't seen her in a few years and had quit Twitter over a year before, so she greeted me like a long-lost friend.

There's an added layer of social pressure when one is out in public with a famous person. There's an awareness that strangers' eyes are on you in a way they wouldn't be on an average day when you're by yourself or with ordinary, non-famous friends.

Thankfully nobody disturbed or invaded our lunch.

After eating we went over to the Tivoli. There were a couple hours before the show but Kelly and Neko went off to get ready. I read a book awhile, then wandered around backstage. An empty theater awaiting a crowd

and a performance has an air of expectation and unful-filled potential about it, like a vessel waiting to be filled.

They gave me an all-access lanyard so I went out to the sidewalk to watch the fans waiting to be let in. After the theater filled up, Kelly and I watched some of opener Robbie Fulks' set from the wings. It was strange to see him in this beautiful old theater after being used to see-ing him at neighborhood bars like the Hideout.

I found my seat and made a bunch of sketches during Neko's set. Afterwards, Kelly offered to let me crash at the hotel, since their tour bus wasn't leaving till morning, but I caught the Metra back to the city.

Sitting in the mostly empty late-night train, I won-dered what it would be like to travel from town to town to perform, eager fans waiting at every stop, maybe a few weirdos scoping out local hotels or eateries, hoping for a glimpse. Dreaming of snatching a photo or autograph or some other souvenir which might shine a bit of refracted glory. I decided, not for the first time, that I prefer not to deal with that kind of pressure and expectation. I'd much rather be part of the faceless crowd.

Mavis Staples

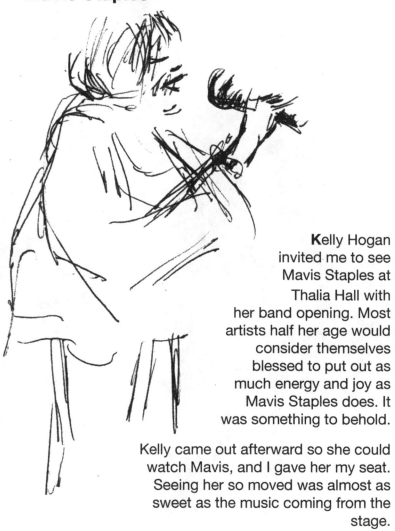

Kelly Hogan invited me to see Mavis Staples at Thalia Hall with her band opening. Most artists half her age would consider themselves blessed to put out as much energy and joy as Mavis Staples does. It was something to behold.

Kelly came out afterward so she could watch Mavis, and I gave her my seat. Seeing her so moved was almost as sweet as the music coming from the stage.

Tijuana Hercules

Kelly introduced me to John Forbes around 2007. His rhythm-and-blues outfit, Tijuana Hercules, never stays the same for long. Early on there was a guy banging an array of pots and pans. Sometimes there's horns. But Forbes is always up front, usually in a snazzy but well-worn jacket, banging out his blues.

We get together now and then to compare notes. He's been driving Grubhub lately, but has held dozens of shit day-jobs just like me. We're both lifers, but our thing often can't pay the bills.

There's something of the carny to Forbes. He wears his hat a little off-kilter and there's mischief in his eye. But he's a sweet guy once you get to know him. He's thoughtful and considerate. The showman/carnival barker onstage isn't all an act, but it also isn't all he is.

When I go see him play a window opens onto a whole obscure history of music he's keeping alive. It's a history kept on dusty 45s and in photos of long-shuttered juke joints. But his performances aren't recreations or tributes to yesteryear. For whatever reason he expresses himself through styles of decades past. It's not a put-on—he channels it, using someone else's means to sing his own song.

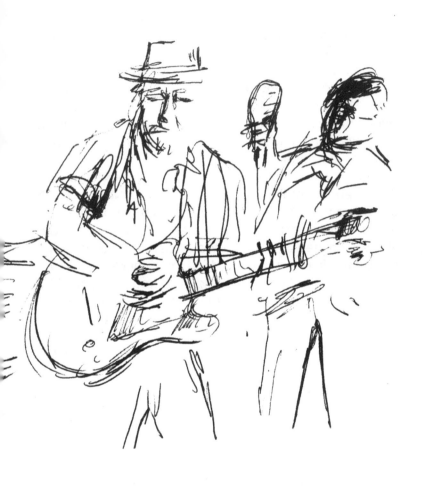

The Time I Drove a Clown to Waukegan

Kelly's friend Mike is a clown. That's not an insult. His name is Mike, but once he puts on the greasepaint he's Puddles. One Thursday, on the rooftop of the Prudential, with Millennium Park and Michigan Avenue for a backdrop, Mike held my wrist, gazed into my eyes, and sang *Happy Birthday to You*. It wasn't Puddles serenading me but it was pretty damn close. Unnerving and sweet in equal proportions.

Kelly, Mike, his wife Shannon and I left the Prudential and went for dinner at Club Lago. Mike not only picked up the tab (after only meeting me a couple hours earlier) but invited me to come see his show Saturday at the Genesee Theatre in Waukegan. The only thing I could offer in return was to drive them there and back.

I got to the Waldorf at 11:30am and we piled Puddles' gear and merch into the back of the Jeep Grand Cherokee I'd just picked up downtown. We drove to Lincoln Square to hang out with Kelly and her dogs, to shop for shaving cream and other toiletries at Merz, and to pick up Puddles' manager, Stuart. Then we continued on to Waukegan.

I hadn't heard of Puddles prior to a month or two before when Kelly showed me some YouTube clips of him singing a song on America's Got Talent. She had talked about her old friend Mike for years, but watching him as Puddles was another thing altogether. I didn't know what to make of it because he was a clown who doesn't talk, yet sings with no irony or eye-winking. I had no idea what to expect from his live show.

We pulled up to the back of the theater and schlepped all the gear inside to two dressing rooms; one was for Shannon, Stuart, and me; the other, for the clown. There was a veggie tray, some beer, bottled water, and a bottle of Templeton Rye on a side table, and a Keurig coffee machine on another. An overstuffed red couch and armchair completed the furnishings.

There was a concert shot of REO Speedwagon on one wall, along with a couple of other photos of acts I didn't recognize. We'd been told that the theater was maintained and supported by the family behind Uline, so it was no surprise to find no shortage of paper products on hand, highlighted by a veritable pyramid of toilet tissue in the closet.

While Puddles was soundchecking, I sat in the armchair reading *Tree of Smoke* and chatting with Stuart, who had set up shop next to the Keurig machine. Turns out he's also Tom Waits' manager, so I told him one of my all-time regrets was not going to see *Frank's Wild Years* at the Orpheum in Boston back in 1987. Stuart said that was the first tour he worked with Waits. Then he tried out a card trick on me. He's a lifelong devotee of magic and both he and Mike are members of the Magic Castle.

A few minutes before showtime I wandered out to the lobby to take in the crowd. They'd sold fifteen hundred tickets—Puddles' biggest show yet, and in Waukegan of all places. A town neither Mike nor Stuart had even heard of. (I had tried to think of the Tom Waits song set near Waukegan and Stuart said Johnsburg, the town Waits' wife is from.) The people streaming into the beautiful old theater ranged from eight to eighty. Everybody looked happy to be there and eager for the show to begin.

I heard a roar from the audience behind me before even settling in my seat. Puddles was making his way down the aisle toward the stage. He settled himself in a chair and started chewing an ever-growing wad of gum.

He would take it out and stick it to the lid of his suitcase, then pop it back in his mouth throughout the night. He never talked—communicating with winks, grunts, and gestures—in other words, being a real clown. But when he sang, the temperature in the room changed. Whether it was "All By Myself," "Where Is My Mind," "Major Tom," or any of the other dozen or so numbers, he delivered them all straight and true. His singing was no joke. But then he'd finish a song and take three minutes straining his back while trying to push a plastic chair a few feet downstage.

At the end of the show it was announced that Puddles would be taking pictures in the lobby next to the table with the merch. (Or *souvenirs*, as Mike had insisted on calling them.) The line stretched back into the theater and lasted an hour or more, but Puddles made sure each fan had a real human moment with him, even chasing a disgruntled middle-aged man outside and taking extra pictures after the man had cursed out security for trying, quite reasonably, to move him along so others could take their turn. In all, they shuttled nearly six hundred folks through. I was almost as impressed with his equanimity during this invasion of his personal space as with his stage act.

Back in the dressing room after the last of the fans had left, Puddles was packed back up into oversized rolling cases and Mike reappeared. We said goodbye to the theater staff and Stuart, who was heading to O'Hare, and drove through the quiet Waukegan streets back to Chicago.

Clowns get a bum rap these days. Between the mediocre Stephen King one killing it at the multiplexes and the bumbling Bozo in the Oval Office, it's easy to forget that clowns exist to spread joy. Go see Puddles and he'll set you straight.

God Alone

My friend Tracy told me her friend Mike was a big fan of my writing. I met him at a show of bar paintings I'd put together at an artist-run storefront in Humboldt Park. He was a skinny guy with long curly hair, covered in tattoos. He acted sheepish and shy around me, which I found kind of funny since I'm pretty much a nobody. He told me he wanted me to do art for a record his new band was putting out.

I looked him up afterwards and saw this same shy guy thrashing about on stages all over the world in front of thousands of screaming fans. His band, The Devil Wears Prada, is pretty big, I guess. I'd never heard of them. That's no knock on them or on me—there's just too much music out there to keep track of.

The artwork he commissioned was for a side project called God Alone. He invited me to visit the band as they recorded at Electrical Audio, then I made four different paintings for them to choose from.

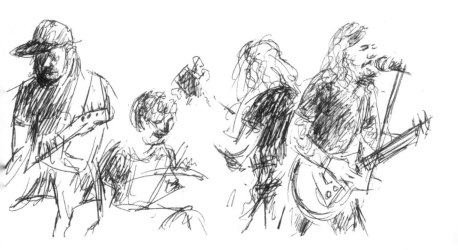

The record came out about a year later, in 2018. They played a Chicago record-release show at a bar down the street from Wrigley Field to a small but enthusiastic crowd. It was a far cry from the sea of fans I saw in videos of Mike's other band, but I got to be a small part of the success of this new one.

I recognized the bartender as the guy who books shows at the Jazz Art Collective. It took me a few minutes to figure out where I knew him from because he was so out of context. Chicago bars are full of music and art people so I shouldn't have been surprised.

Mike gave me a couple records with my cover paintings, then we said our goodbyes. He was going on tour and I was taking the bus home.

MR. WRONG

Slim Cessna's Auto Club

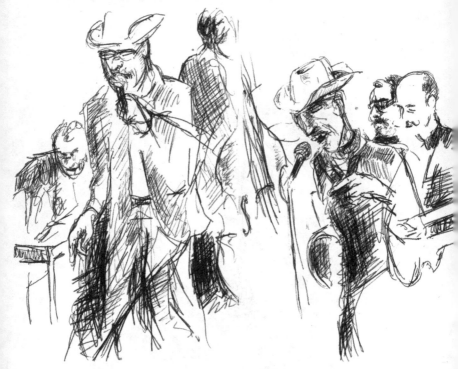

I was sitting at the half-moon cocktail table nearest the stage at the Hideout when a young woman noticed my sketchbook and asked to look at the drawing. We wound up writing notes back and forth for the rest of the show, and we left together.

We lasted a couple months. One night she started hitting me outside the Rainbo Club and I walked away from her. She showed up at my house at 3am, sobbing, unable to understand why I'd left.

In retrospect it seems important that we'd met while watching a band of guys dressed like spaghetti-Western extras singing sped-up country murder ballads.

A few months after I broke it off with her she wrote me a sweet letter apologizing for how she'd been with me, blaming it on the boozing she'd since given up.

I ran into her a few years later at a Wicker Park coffee shop. She looked great. I wanted to ask for her number but she left before I had the chance.

Silver Jews

David Berman's best phrases follow me around like a smart aleck sidekick, poking me in the ribs one minute, making me want to cry the next: horseleg swastikas, ring-finger tanlines, and alleys which are footnotes of avenues.

I had a roommate who listened to these songs on repeat and I resisted them for the longest time. But she moved away and we lost touch and then she died. Now the Silver Jews sing her obituary to me every time I put them on. I've gained a lot of my own references for Berman's words but on some level they will always be a memorial to a woman who didn't want to live and finally succeeded at not living.

When Berman announced he was quitting music in 2009 I was pissed at him. I wanted more of his weird poems set to shambling music. He said the music business had become soulless and corporate and he saw no

path forward. But by getting out of the game he robbed us of his voice and his words. It wasn't fair.

The band played at the Metro, then a couple more shows nearer their Nashville home, and that was it for a long time. Berman had a weird blog called Menthol Mountains for a bit, but abandoned that as well.

Then, in the spring of 2018, I saw him standing at the bar at the Empty Bottle. It was like seeing a ghost. I looked away, looked back and he was still there. Then a minute later he was gone. A lot of that audience was people from Drag City, the Silver Jews' label. Later I asked my friend Bill if that was really Berman and he confirmed that it was. He'd been introduced to him earlier that day. Berman was in town working on something.

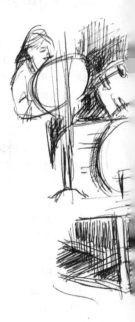

Maybe there'll be more songs. Then I could stop being mad at him for walking away too soon.

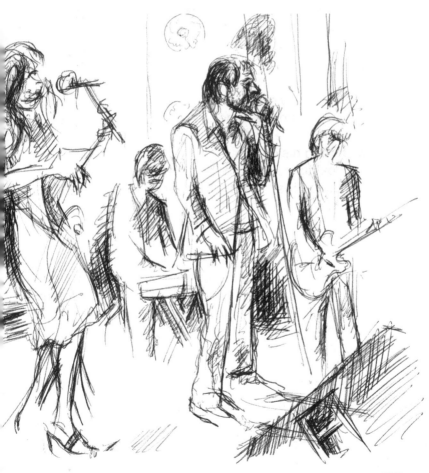

Bill Callahan

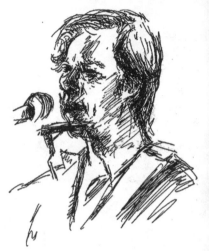

Bill Callahan played in a greenhouse surrounded by vegetation at the Garfield Park Conservatory. It was like a stage set summoned by one of his songs. A strange tapdancing woman opened the show with a routine which baffled most of his fans but obviously delighted Callahan because he praised her repeatedly before starting his own set.

The next time I saw him he was at Alhambra Palace. It is a nightclub/restaurant on Randolph Street's restaurant row which resembles something out of the Arabian Nights by way of Las Vegas or Atlantic City. The halls inside were crawling with smartly suited security men with earpieces. As if the crowd might contain risky elements rather than a bunch of retiring, aged indie-rock types out for a night of sad songs. Looking around at the very real-looking mosaics and decor I wondered how many millions were sunk into this strange fairy-tale palace, and to what end.

Callahan is obviously sick of playing venues his loyal fans are used to. His songs provide all the setting anyone needs, anyhow. As if you're on horseback beside him traversing an endless expanse, entranced by his blunt but obscure poetry.

A friend who has passed on used to play his old band Smog all the time. Because of that I used to avoid his music. Now it has mostly transcended my memories. But every once in a while, Callahan's plaintive voice still sings me her tributes.

Califone

On Friday the 13th I rented a Zipcar and drove to Oak Lawn to see Califone play in someone's living room. Getting there entailed going through Beverly, a neighborhood I'd lived in for three years. Thinking about that time as I drove lent a sadness to the trip, but it probably wasn't the worst state of mind in which to hear Tim Rutili's wistful, ramshackle songs.

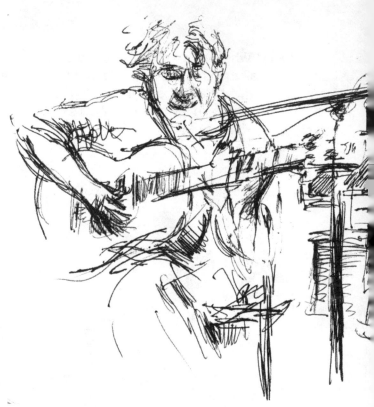

It's often odd to be in a roomful of strangers who are each having a personal experience listening to music. It's even more awkward when that room is a suburban living room in some stranger's house. I overheard people complimenting the blinds and the lighting fixtures. The couple on the couch next to me introduced themselves and then we didn't utter more than two words to each other the rest of the night. That's normal in a bar or nightclub but strange in a private home. There's an expectation of familiarity or intimacy there, but the fact

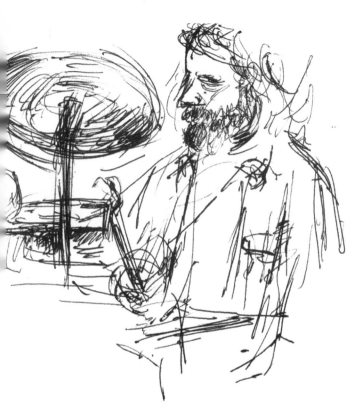

that the thirty or so people crowding the space had paid to see musicians who could pack a venue holding hundreds lent an unreality to the night.

It is a testament to Califone that I was able to get past the social anxiety that the setting presented. Afterwards, a couple people who had seen me drawing asked to see the sketches and said nice things about them. The hostess's cousin even took cellphone pictures.

I bought a record at the merch table—which was set up to strategically block access to the second floor of the bungalow—and ran out into the rain. The guys had played a half hour longer than advertised and I had to get the Zipcar back to Pilsen quickly in order not to incur a late charge. When I pulled into the parking spot off Halsted, it was pouring. I used the shrink-wrapped record as an umbrella as I ran to the bar for a nightcap.

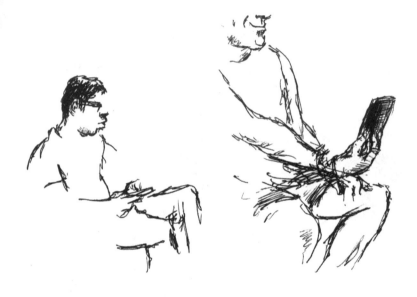

SOCIAL MEDIA

Food Truck Social

I went to Humboldt Park two nights in a row to see bands play at an idiotic food truck rally. Normally I wouldn't be caught dead at an outdoor festival of any kind, especially one centered around overpriced, mediocre street food, but the bands in question were the Gories and Endless Boogie. I hadn't seen either play in person though I've been a fan of both for years. The only place they were playing in Chicago was this glorified ribfest for the cool crowd. I had to go.

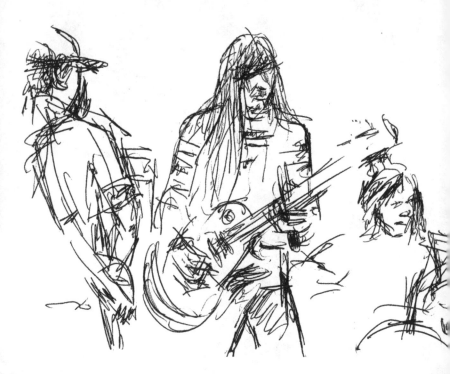

After Endless Boogie played Saturday night I waited around to see if the band was hanging around, maybe selling merch. I wanted to show them the sketch I'd done. Paul Major came out after a while and talked to the three or four of us loitering around the side of the stage. He liked my drawing so I said I'd email him a copy. He thanked me, saying he wouldn't see it till he got back home from tour because he doesn't take a computer on the road. Sure enough, he emailed me about a week later to thank me again. It felt like a genuine moment with someone whose work I love—something that doesn't happen very often. Part of why I draw people playing music is to bridge the gap between the stage and me.

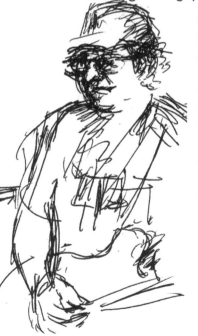

Sometimes nothing comes of it, but every so often, it does exactly that.

The night before, on the same stage, the Gories bashed out a set of their fractured blues. Mick Collins and I have become friendly over the last few years. He used to ask me for Russian translations on Twitter, and we had drinks the last time I was in NYC. He had a food ticket, so we wandered down the line of trucks so he could grab something before he played.

I told him that coincidentally Tim Kerr, an old bandmate, was having an art opening in the burbs the next night. After an uncomfortable pause, Mick told me Kerr hates him. Years ago they were in a band together called the King Sound Quartet. Apparently when they were recording a follow-up to their first LP, Kerr wanted him to scream as loud as he could and Mick took exception. He didn't think Kerr had a right to tell a black man how to scream. Kerr brought in a different black singer to finish the session. Mick said Kerr has been badmouthing him ever since, costing him chances to work with a bunch of people. I dropped the subject and we chatted about other things while he tried to eat the gloppy kimchi concoction he'd settled on.

Seeing two great bands playing in the middle of a blocked off boulevard downwind of a bunch of vehicles peddling gussied-up carnival slop was a bittersweet experience. I don't begrudge guys who've spent decades bashing it out for pennies in dirty basements for taking a well-payed gig when it's offered. The people who organize these festivals grew up idolizing Mick Collins and Paul Major, and by hiring them they probably feel like they're repaying part of their debt. But performing as background music for masticating yuppies can't be anybody's idea of creative fulfillment.

Low

Low followed me on Twitter and I didn't know why. They didn't follow many people and I wasn't even following them. I'd heard a few songs but had never seen them play, or known much about them at all, for that matter. It nagged at me so I asked them (or whoever ran their Twitter) what I'd done to get on their radar; I was told it was because I drew on coffee bags.

I'd been working at a coffeeshop called Hardboiled Coffee and illustrating the white bags we used to sell our beans. I'd draw Chicago scenes or ballplayers or rockstars. A few customers even commissioned bags. I'd post each new one on Twitter. I don't know how the band from Duluth stumbled upon those posts but I was flattered they took notice.

I started listening to their music. It made me wish I'd found it sooner. I drew Low on a Hardboiled bag and sent the pound of beans I'd roasted myself that morning to Duluth.

I saw them play at Subterranean in Wicker Park later the same year. You could've heard a pin drop, that's how reverent their audience was. It was like church service but with slow-burn guitars augmenting the choir-like voices of Alan and Mimi.

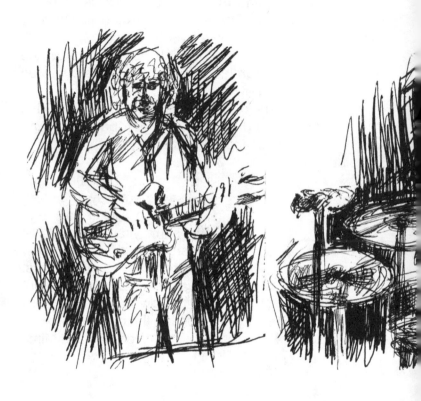

Next time was at the much larger Thalia Hall. It was a beautiful show but lacked the intimacy of the Subterranean one. There's nothing that can replace the first time you see a great band play in person.

I quit Twitter in 2015, and Hardboiled Coffee closed shop not long after, but I still listen to Low. Their record *I Could Live in Hope* is a favorite of mine to play at closing

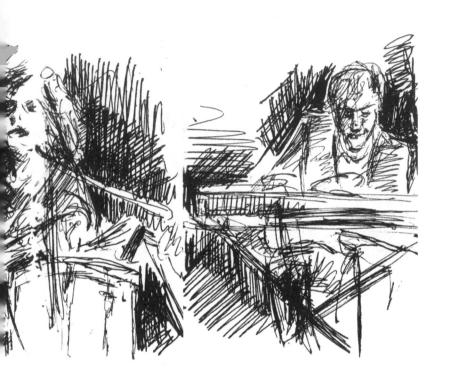

time at the Skylark. Their mournful musical prayers are a good way to send the last of the drinkers off into the night.

Wussy

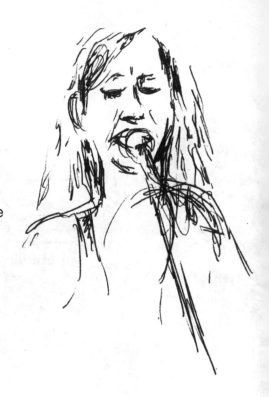

One of the people I miss shooting the shit with on Twitter is Patrick Monaghan. Patrick and his wife Julia ran the late lamented Carrot Top Records—home to the Handsome Family, Daniel Knox, Antietam, and countless other greats—and before that, they were involved with the equally missed Chicago rock club Lounge Ax.

When I see Patrick and Julia at a show, I know I'm on the right track.

It was no surprise to see them at the Red Line Tap for the great Cincinnati band Wussy, but I'm baffled anytime someone I want to see plays that weird little Rogers Park bar. Wussy, Dexter Romweber, and Kid Congo Powers must either have the same booker, or they all owe the owners of this joint a favor. Nothing else ex-

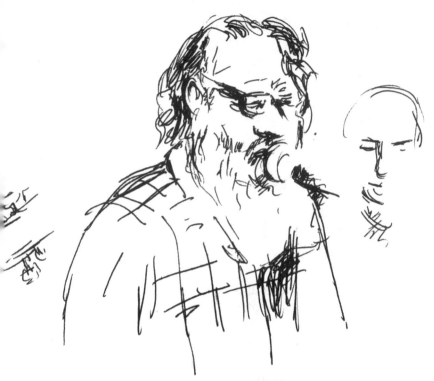

plains why these great acts keep showing up at such a remote hole-in-the-wall. It's almost perverse, but they're all iconoclasts, so maybe playing at a venue nobody knows appeals to them. I have to remind myself to check the club's schedule regularly so I don't miss somebody I love because they flew in under the radar.

The Handsome Family

"The Woman Downstairs" is one of the best songs written about Chicago that I've ever heard. I thought about the wind screaming down Ashland Avenue all the years I drove a cab in this town.

The Handsome Family's been gone from Chicago longer than they were here—they left for Albuquerque long ago—but I'll always think of them as a Chicago band, even if their murder ballads and weird western waltzes rarely reference the city anymore.

"Weightless Again" is one of the best songs ever written about the difficulty of everyday life for those of us who have difficulty getting out of our own heads and actually living with others. And "My Ghost" could be theme song for anyone whose mind sometime wants to kill them.

I once drove all the way to Iowa City to see them

because they weren't playing Chicago that year. I drove back right after they stopped playing. It was well-worth the eight hour roundtrip.

When I heard "Far From Any Road" over the opening credits of *True Detective* I loved that show before seeing a single frame.

I remember Patrick from Carrot Top—their record label—on Twitter, proudly tracking every international Billboard Top 10 they broke with that song over a decade after they'd recorded it. That TV show gave them a whole new audience. I hope the newcomers stick around because, unlike *True Detective* (which fell flat on its face in its second season), the Handsome Family have cast their weird spell for decades, and will continue to do so for decades more.

I had tickets to see them in Chicago in 2018 but couldn't make it, so I drove to Milwaukee a couple days after so I wouldn't miss them. I found Shank Hall after a couple wrong turns, then, with a few hours still left before the show, I sat at a Starbucks to write up a review of some movie I now can't remember. A woman in almost theatrically-exaggerated street urchin garb sat next to me and tried repeatedly to interrupt my work with her yammering. I learned (without wanting to) that she went by "Gypsy" out on the streets.

I arrived at the club at 9pm sharp and was the first customer. There was an oblong bar near the street-side window and a stage with some cocktail tables in the back. I took a spot next to a couple tables marked "Reserved" up front, ordered a drink, and opened my book.

As opener Chris Crofton started his set, the "Re-

served" tables were taken by some middle-aged couples. Rennie from the Handsome Family came and sat with them for awhile. One of the men kept peering at my sketch of Crofton, then blurted out that he wanted it. I like to keep my sketchbooks intact, so I don't usually give away or sell pages, but because the guy was so brazenly forward (and connected with the band), I decided to make an exception. I took out my Swiss Army knife, cut the page out, and handed it to the guy. He seemed overjoyed, and he showed it off to all his friends. Then he left it on the table and walked away to sit somewhere else.

I went back to drawing, trying not to be irritated, but the drawing sitting forgotten on the next table was like a magnet of bad feelings. I waited as long as I could stand it, then snatched the drawing up and slipped it back into my sketchbook.

The Handsome Family played a lot of old favorites; they were celebrating the 20th anniversary of their great *Through The Trees* LP. The club wasn't full and I don't know how familiar the audience was with the band apart from the theme from *True Detective* but I was just happy to hear a bunch of music I know by heart.

Racing back home down a mostly empty interstate, I thought again about that guy asking for my drawing, then forgetting all about it. There have been many people who have paid me money for my work now, but this jackass assumed that, not only could he have it for free, but it was perfectly fine to discard it once his attention drifted elsewhere. I thought about the great band I'd just listened to and wondered how much indifference they

have to deal with as they go from town to town. My great advantage is that I rarely have to face the callousness head on, because what I do isn't a public performance. It's lousy though, and it makes me feel less of people.

75 Dollar Bill

I never expected my favorite new band would feature a man sitting on a plywood box and using it as a drum kit, but that's the setup of 75 Dollar Bill.

There are some bands which benefit disproportionately from being seen firsthand. 75 Dollar Bill does so much with so little that it's best to be there to watch them do it. Although they often have as many as a half dozen friends join in, at its core the band consists of Che Chen on guitar or saxophone and that aforementioned plywood box percussionist, Rick Brown. They both add

from piles of noisemakers and assorted doodads scattered around their feet as they play.

Many of their numbers don't have an obvious beginning or end. They lock into a groove, adding flourishes and grace notes now and again. One could imagine them starting one of these and just keeping it going into the vanishing point.

What they play is probably blues, but blues like John Fahey rather than Robert Johnson. They use that language, but fit it into a minimalist structure in which repe-

tition is used sometimes to gather steam, other times to meander, or tread water. They sound like those African desert blues combos, but translated into an NYC subway busker dialect.

Rick Brown's plywood box is human expression pared down to bare essentials. I've seen rock drummers in a cockpit of high-tech gear not even begin to approach the rhythmic feel Brown gets from that plain box.

They played early on a summer afternoon at the Hideout Block Party, then later that night at the Co-Prosperity Sphere, which is a couple blocks from my house. Afterwards, Chen told me he could see me scribbling away as he played. I wondered whether my weird habit was a distraction, but decided his noticing was a by-product of the way 75 Dollar Bill makes music. They have to be hyper-attuned to minute changes in the environment since they work so much with repetition. By playing notes over and over, their effect on the room can become more discernible. Maybe my sketches added some bit of flavor to their ever evolving stew that night. That's my hope, anyhow.

Protomartyr

The day before Protomartyr played at Schuba's, I had a meltdown at the Pitchfork Music Festival.

The publisher of my second book had generously offered me table space to hawk books, prints, and art at the Book Fort for no charge. I was also scheduled to do a reading that afternoon. But I barely lasted two hours of the three-day festival.

It was a crazy hot morning when I got there that Friday. There were already lines of kids waiting for drinks, food, free silkscreened t-shirts, and merch. I watched all the happy young people milling about and thought nothing but horrible things. Why was I here? Why were they? What was I thinking, wanting to sell my crap to these people? Why would I want to sell anything to anybody at all? The relentless sun was no help. I don't respond well to heat under the best circumstances, but combined with being in a place I didn't want to be, it made for a cocktail of impenetrable darkness inside my head.

I mumbled some likely incomprehensible apology, packed up my things, and got the hell out of there. I was gone before the first band played a note.

I had a ticket to see Ex Hex at the Bottle that night but was too thrown by what had happened earlier to want to leave the house. Protomartyr was to play the next day at the festival, then go across town to Schuba's. I made myself go back outside to see them.

There's a gauntlet to run when seeing shows at Schuba's. That gauntlet is the bro bar one must traverse to get to the music room in the back. Every time I've ever

been there the front and the back seem like separate ecosystems. Rowdy Cubbie fans dominate the bar no matter the season, while the type of people in the music room depends entirely on what band is playing. It's an odd, sometimes uncomfortable negotiation getting from one world to the other.

Before I got to Schuba's, I had deleted Instagram from my iPhone. It was the last social network I belonged to. I'd signed up a few months earlier, just before I'd deleted my Twitter account, which I'd used compulsively for the previous seven years. I figured Instagram might be more manageable and less all-consuming, but it turned out not to quell any of the cravings, while delivering little of the rush which Twitter's pellet-sized but never-ending updates gave. (Instagram was methadone to Twitter's heroin.) After I made a sketch of the opener, Bully, I reached for my phone to snap a pic and post it before realizing there was nowhere to post it to.

Protomartyr came on and I made another drawing. This time I just scanned the packed room afterwards and realized I likely didn't know a soul here.

Without the veil of social media my situation was laid plain: I was a weird forty-five-year-old in a club full of much younger people who had probably followed these bands from Union Park after roasting all day in the sun. They were sunburned, sweaty, and woozy from booze and whatever else they'd ingested, but mostly they were drunk on music. At least we had that in common.

When I got home, I scanned the sketches and uploaded them to my website. Then I looked up the bands' websites and emailed them their drawings. After a decade, starting with MySpace around 2005, there would be no common area for me to share this work anymore. I would now have to address each and every subject of my sketches personally if I wanted them to look.

In the weeks that followed I got several emails from social media acquaintances worried about my sanity. I found out quickly just how few actual friends I have. Without the convenience of a shared platform most of my "friends" don't want to bother. Meanwhile life goes on.

I go and sketch at more shows than ever, even though the instant gratification/approval of Twitter and Instagram is gone. I've found out I don't need it. Every now and again someone at a show will notice me sketching and ask to take a picture. Sometimes these photos end up on social media and I'll come across them sometime later. But they're like rumors from a faraway town, rather than news from my own.

I've never gone back to Pitchfork either, and have no plans to ever do so again.

Krystle Warren

One Friday night I went to the Hungry Brain to listen to Krystle Warren sing. I hadn't heard of her until that morning, when my friend Charles sent out a mass email about the show. I listened to a few songs on YouTube and decided to go. The Hungry Brain is a spot loaded with resonance from the past, though it recently reopened under different ownership and lacks much of its former shambling charm.

Listening to Warren sing and play guitar unamplified in the middle of the room, away from the stage, was a beautiful thing.

Afterwards, out on the back patio, I introduced myself and we chatted a bit. We talked about Chicago, about Kansas City—where she's from—and about Paris, where she lives now. A couple other musicians were grilling leftover hot dogs from Memorial Day, and almost everyone was smoking. I'd been to the Hungry Brain many times before, but it was completely different this night. Maybe because of making new friends, or because the bar had been transformed and renovated, or perhaps just because I allowed myself to see it in a new way: new sounds in an old place that is new again.

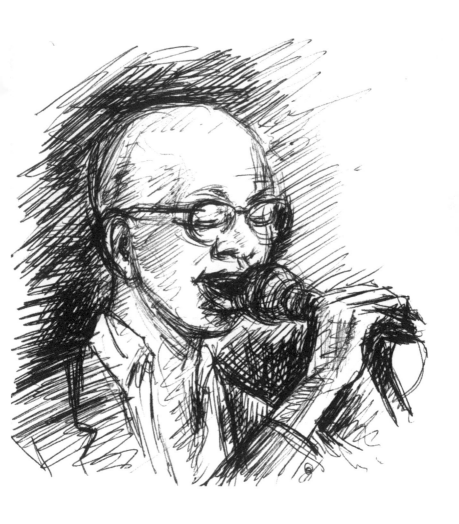

195

TWO BIRDS w/ ONE STONE

Jazz Art Collective

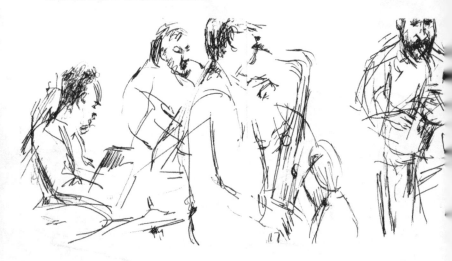

Most Wednesdays throughout the year you can show up at the Jazz Art Collective's loft space on Hubbard Street and hear a band cover a whole record top to bottom. The first time I went, a group called Garden of Souls was tackling an Ornette Coleman album.

I noticed there was a guy painting away at an easel up against the wall of windows which opened onto the city. There were brightly colored abstractions hung on the raw brick walls.

After the show, I went up to the MC and asked about how they chose the artists. He invited me to send him some links to my work. A couple months later I was schlepping a bunch of my paintings into that loft.

That night, a different band was playing a Herbie Hancock record. The room was full and the music was good but my paintings just didn't cut it. Whether I was

self-conscious after being introduced as "the featured artist," angsty about feeling like I was on stage performing, or maybe just suddenly aware that sumi wash paintings were the wrong medium, it just wasn't happening. I agonized over it while packing up my work and carrying it out to the Zipcar.

Normally when I draw music there's no one in the audience who's come to watch what *I'm* doing. Oftentimes people will come over at a show and look, and I have no problem sharing, but that's entirely different than scheduling an event at which a crowd shows up to be entertained by my doodling. My place is in the audience rather than on a stage. My stage is a piece of paper and the audience is better off waiting till my performance is done to take a look. In that way painting and music are entirely different. Although both happen over time, painting is not live and in the air for others the way music is.

A few weeks later I was back at the loft to hear an outfit called the Bonzo Squad do Stevie Wonder's *Innervisions*. In between wiping away the tears, I managed a halfway decent sketch. Everything was right as rain again.

Columbus Roadtrip

One Tuesday morning I rented a car and drove to Columbus, Ohio. I've been to Columbus three times before. The first time was in 1997 when a friend of a coworker at Pearl Art & Craft hired me to move him there in my 1978 GMC van. I was back in Chicago the following morning

on no sleep to work my shift at the store. My other two visits were to see Cheater Slicks play. One of those trips was made in the Yellow Cab I was renting at the time.

I'd seen a post online that they were opening for Lydia Lunch at a club called the Ace of Cups and decided it was reason enough for a road trip. Lunch is one of those New York punk legends I don't know much about.

There's a few of them still left wandering about, still under the radar, but with small, devoted coteries keeping them afloat. I always have a soft spot for people who are still fighting the good fight in the face of near-universal indifference.

Mid-way through the six-hour drive, I stopped at a Starbucks to use the wifi and booked a room for that night at a Motel 6 on a road called Olentangy. My plan had been to meet Tom from Cheater Slicks at his work before he left at 4pm to load in for the show, but I had forgotten that Ohio is on East Coast time, so I wouldn't make it to catch him with the hour difference. I screen-shotted the Google Maps directions to get to the motel and drove on.

After a couple hours and several wrong turns and a brief stop at the motel, I walked into the Ace of Cups. Tom was standing by the bar talking to Bob, the drummer in Lydia Lunch's band. Tom and the rest of the Cheater Slicks had crashed at my ex-girlfriend's house the last time they played Chicago a few years back. It was good to see him again.

We went out back to the patio where Tom's brother Dave was smoking and having a beer at one of the picnic tables. Gradually, the other tables filled with waiting groups of fans as well. It was a mostly older crowd, which wasn't much of a surprise. Lunch has been around since the late 70s and Cheater Slicks have been together since 1987. Not exactly teeny-bopper fare. One particularly grizzled character had made the drive from Cleveland. He came over to greet the band, then relit the butt of a stogie and stood around grinning toothlessly at

the rest of us.

Cheater Slicks played a beautiful set. They're most commonly described as a garage band, but they have long ago left the sideburned, Brylcreemed, and cuffed-denim crowd behind them. They play loud, feedback-laden music which gets more and more abstract. There's an inward sort of intensity to what they do and that may be the only consistent thread over the nearly thirty years I've been going to see them. Afterwards, back out on the patio, Tom lamented that they sounded like smooth jazz. I told him Kenny G and Chuck Mangione would never acknowledge what he'd just done on stage as their music, and that made him laugh.

I listened to a bit of Lydia Lunch's set, then wandered back outside. There was something studied and overly professional about their sound. This was less like punk rock and more like a chamber ensemble performing classic repertory. I went over to the merch table after they were done and would've thanked Lunch for coming to play but she was entirely consumed in tense negotiations with the club owner about getting paid. I bought a reissue of one of her early LPs with a fancy block-printed cover, said my goodbyes, and took off.

The next morning I checked out of the Motel 6 and went to Nancy's Home Cooking for breakfast. I chose it after a quick Google search identified it as the closest non-chain spot to eat. I ordered the garbage omelette with grits and spent a happy half hour taking in the collection of handwritten signs which dominate the diner's decor. The best was the one announcing that they no longer accepted boob or sock cash unless the customer

was prepared to receive change from a similar source. One of the cooks walked by in a t-shirt which claimed theirs was "The Food You Dream of in Jail." Had those been for sale, I might be wearing one right now.

Aside from seeing one of my favorite bands, there was one practical aspect to this trip. I'd been tracking the availability of a particular Ikea frame online for weeks without success. When I told my friend Tracy about this she suggested I check the Columbus store, and lo and behold, they had plenty. I walked in through the massive revolving door right as they opened at 10am, loaded a flat cart with five boxes each holding ten Ribba frames, and pushed it toward checkout. There, the very friendly cashier asked all about what I was going to do with so many frames, told me she wanted a giant version of van Gogh's Starry Night over her bed, and said both her neighbors were artists—one did landscapes while the other focused on religious themes. I wished her a good day, then drove to downtown Columbus.

I had an hour to kill before lunch with Tom so I went to the art museum. I spent most of my time there looking at a show of Soviet and Russian art from 1960 to 2010. There was some compelling stuff but my overall impression was one of sorrow at what my country of birth had done to generations of its artists. The brutal governmental constraints covered every surface of every artwork like a patina. Even the most strident pieces of agitprop carried a grim, defeated air. The blazing July sun outside was a jarring contrast to the sad, oblique work inside. I blasted the rental's AC and drove to Tom's record store.

He's been working at Used Kids for twenty years now. He doesn't deal with the public, preferring to work in the office cataloguing, pricing, and buying collections of LPs. He has a graduate degree in library science but there are few jobs to be had in that field these days. Record collectors are librarians of a sort, so at least he gets to work in a field connected to his interests. Still, he's hoping to get out one of these days. We got deli sandwiches from a supermarket called Lucky's and took them back to the store to eat.

That night I sweated buckets humping Ikea frames up my three flights, then returned the car to Enterprise downtown. I was only gone a day and a half, but the trip went a long way towards rearranging my headspace. The biggest reason to travel is to refresh one's feeling of home.

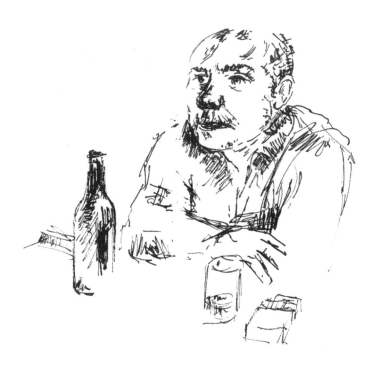

O' DEATH

O'Death

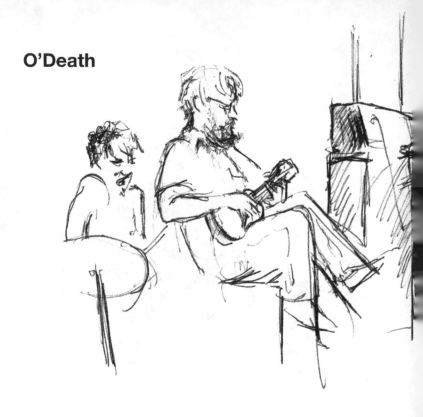

Cool Brooklyn kids doing old-timey bluegrass/country isn't much of a selling point to me, but these guys, who named themselves after the most country country song ever, seem to mean what they're singing. Or maybe it's method acting. I don't know, but when I caught their act at the Hideout Block Party, I bought it.

Authenticity has as many minefields as any aesthetic battleground. Does some part of the country, at a particular time own, say, banjo or fiddle music? If a painter

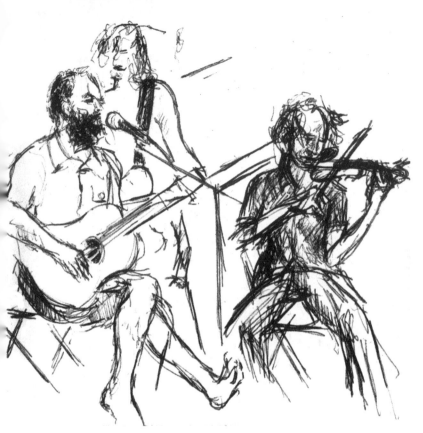

in 2018 paints from observation, is he coopting an out-moded 19th century style rather than actually attempting to relate what's in front of his eyes? Intent has a lot to do with gauging someone using old means. Sometimes it's impossible to say what you need to say by the most current methods. So you reach back through history for tools which had worked for others before. It will never mean what it meant when the methods were first employed, but that doesn't mean that they are obsolete, or that they should die with their originators.

I don't know why O'Death chose old-timey blue-grass, but I have to believe it was because they could find no other way to sing their songs. You use whatever means you have at your disposal. If that's banjos and fiddles, then so be it.

Haskell Wexler

Medium Cool, Haskell Wexler's great half-documentary/half-drama set within the protests against the 1968 Democratic Convention, was one of my first exposures to Chicago, along with Nelson Algren's *Never Come Morning* and *The Man with the Golden Arm*. Algren had left the city and passed away by the time I arrived here in 1990, but Wexler was still very much with us more than two decades on.

In 2012 he came back to town to document the NATO protests. I was still driving a cab, so I had a front row view of how that event transformed the city. It was like a ghost town under enemy occupation. Police departments from all over the country came and locked down the streets—a vast overreaction against a largely peaceful protest demonstration.

Wexler's *Four Days in Chicago* documented the scene from close up, just as he had done during the 1968 Democratic Convention in *Medium Cool*. I went to a Q & A at Columbia College and happened upon Wexler sawing logs in the lounge beforehand. He was 91 years old and would pass away in 2015. It was humbling to think about all this guy—now taking a nap before my very eyes—had done and seen.

Joe Frank

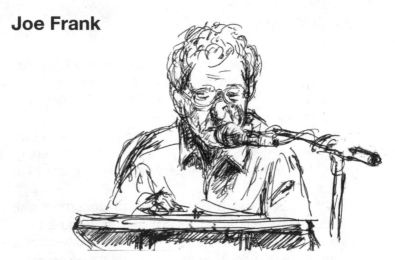

I was introduced to Joe Frank by an English teacher at SAIC my freshman year in 1990. Our homework was listening to Frank's Sunday night NPR show "Work in Progress."

Frank's deep, confessional tone seemed to come from a parallel nighttime universe. He was a lonely man with a microphone telling of his life. Fact and fiction were woven so tight in his sagas there was no telling one from the other. I loved his phone conversations with ex-girl-friends—some filled with regret and longing, others with recrimination and bile.

In his live show at the Steppenwolf Theatre, Frank sat at a desk and read into an old-fashioned microphone while a guitarist provided a live soundtrack. It was beautiful to see the man who'd woven those nocturnal noirs for decades now here in person—though his work is best experienced alone, emanating from a radio speak-

er, preferably late at night.

Afterwards, the frail Frank was escorted to the theater's lobby for autographs and photo ops. I gave him a copy of my cabbie book, inscribed with a thank you note for inspiring me to write down my own stories. He looked at the cover and remarked, "Oh, you're a hack."

Frank died in 2018, a few months short of his eightieth birthday. He'd been struggling to pay health bills for years. There'd been several fundraisers recently. It's barbaric that the U.S. doesn't take care of its cultural treasures. Frank shouldn't have had to fret over doctor bills after all he'd given to the world. Instead he died unknown by the majority of Americans, in dire straits.

Art Shay

I shared the stage at the Hideout once with famed photographer Art Shay and noted artist/actor/poet Tony Fitzpatrick for an event which was billed as an evening with legendary Chicago artists. I took my sketchbook up on stage figuring I'd be lucky to get a solitary word in with those two epic talkers on the mics. The surprise was that Tony barely got a word in, either. The then-93-year-old Shay has never passed by a chance to hold forth. I just sat back and tried to catch a likeness of the man doing his thing.

Now he's gone, possibly telling St. Peter or some other heavenly gatekeeper (if there's a hereafter) about

knocking around the slums of Chicago with Nelson Al-gren, or fighting Nazis in World War II, or about how much he loved his wife. With his passing one more link to the legends of the 20th century has been severed.

Jeff Mangum

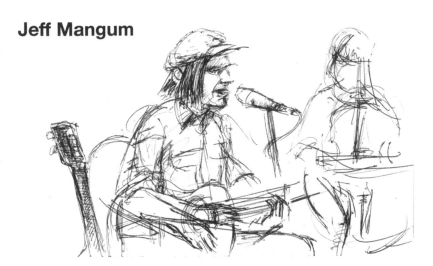

Reclusive genius-type Jeff Mangum emerged out of seclusion around 2013 to grant his acolytes a chance to bask again in his homespun radiance. Elfin, granola-loving neo-hippies the world over danced a jig in exultation.

Their guru wouldn't permit soul-ensnaring shutterbugs to capture his countenance, so the *Chicago Reader* cleverly sent me to sketch Mangum in their stead. The drawings would accompany Miles Raymer's write-up.

We met up beforehand at the Lincoln Tap to inoculate ourselves with whiskey against the waves of adulation to come. I don't know which of us was less interested in what we were about to see.

The story of Mangum's band Neutral Milk Hotel, and particularly *In the Aeroplane Over the Sea*, has hardened into myth in the decade-plus since he's disappeared from public view. I think a song or two of his wide-eyed Christian psychedelic folk stylings goes a long way, but

that opinion might've landed me in hot water at the Athenaeum that night.

Something called Elf Power opened the show, then Mangum walked out and sang his repertoire to an hour of nonstop cheering. I did my work, then spent the rest of the time looking at the audience. I didn't know what about Mangum made them so rapturous, but I was fascinated nonetheless—it was like those National Geographic articles about exotic cultures.

Raymer published his article with my drawings, I got paid, and no more was said about it. I don't think I've intentionally listened to a Neutral Milk Hotel song since.

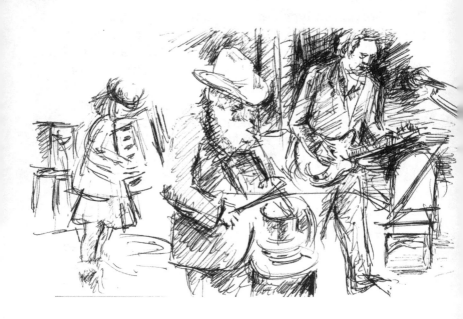

Shane MacGowan

I went to see Shane Mac-Gowan and the Popes at the Vic with a coworker from the Thai restaurant. She was half-Irish, and MacGowan is a patron saint for many from that isle.

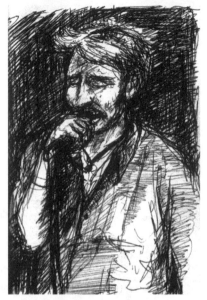

The crowd was full of flag-waving fools. My friend went downstairs to get closer to the stage, while I stayed in the balcony. MacGowan was completely off-key and out of step with his band, who had to soldier on with a singer who couldn't sing his own songs. Then he turned away from the audience and threw up. A young man ran out promptly and mopped it up.

The show went on but I could no longer bear to look. The fools in the pit kept cheering and waving their Irish flags, egging him on. It was one of the most depressing things I'd ever seen in my life.

Afterwards at Lazo's Tacos on Western, my coworker and I got into an argument about what we'd just seen. Her emerald-colored glasses made her insist there'd been nothing wrong with MacGowan's performance, or the crowd's reaction to it. To me it was like cheering a multiple-car pileup.

Years later MacGowan was back in town to play the Congress Theater. I picked up a woman in my cab afterwards and told her my story. She said he'd cleaned himself up and could now sing his own songs again. I was glad to hear it.

Fred & Toodie Cole

Fred and Toody Cole from Dead Moon played an early "intimate" set at the Empty Bottle.

What "intimate" usually means is quieter or softer, but they bashed out their tunes just like they would've with a drummer and bigger amplifiers. They'd been at it for so long, yet they showed no sign of quit. (Not surprisingly, many of their songs are about persistence, of going on despite long odds.) Watching them keep going was inspiring. Another band offering a way forward, rather than a nostalgia trip.

A couple years after this gig Fred Cole passed away. I'll never forget that ragged-looking man up on the stage belting out his songs. He didn't look well, but he got up there anyway, and did it for as long as he could.

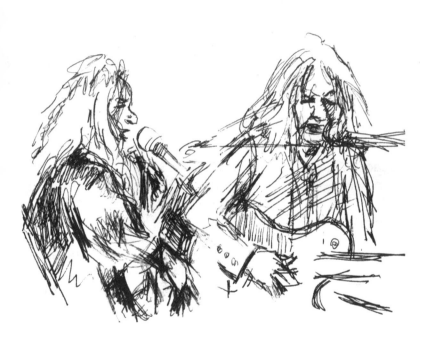

Tom Petty Fan (10/21/17)

The first thing I put on when my bar shift starts is *Damn the Torpedoes*. Ever since I started bartending at the Skylark, I've been taking out CDs from the library and copying them to iTunes, so I can have a wider range of music to play Sunday nights. They let you take ten out at a time, and I figure they'll probably eliminate CDs altogether before too long, so I'd better take advantage in the meantime. It's a chance to listen to things I don't know, forgot, or don't like enough to pay for.

Tom Petty was already big when I first began choosing what music to listen to on my own. He was on MTV dressed as the Mad Hatter, telling me not to come around there no more. Before that, he was getting out of a dusty spaceship, singing about how I got lucky. He looked like a praying mantis skulking around. Even in close-up it felt like he was far away. The wide-set eyes, pencil-thin nose, and big toothy mouth made him look skeletal—not exactly menacing, just remote and knowing. Spectral. His songs were on the radio all the time back in the 80s, which was the last time I listened to music on the radio.

I got a couple of his CDs from the library after he died. I never bought any before and figured now was the time to give them a shot. The songs stand up a lot better than much of the roots-rock Americana he's usually lumped in with. I doubt I'll be going back to Springsteen or Mellencamp when they pass. The working-class-hero act doesn't age so well in my book. But Petty's different. His laconic tunes became anthems without trying to be, unlike those other guys' work, which seems to oversell

their authenticity.

A young man sitting by the taps, nursing a Schlitz tallboy, slurrily sings along from the first verse of "Refugee" on. He asks if I like Petty and I nod sure. Says he got to see him live a couple times and is shocked to hear I never did.

"Those guys are like athletes. They really cranked it out."

He goes back to singing along badly as I walk away.

"I can't believe what a big deal everybody on social media makes when famous people die these days. I mean, he was like sixty! I'm thirty now and I probably won't make it to forty."

Be careful, I tell him, *you might surprise yourself and live to old age the way Petty did.*

He asks how much the Pabst is, and when I say it's $2, he orders one.

"I'm poor."

I ask Jesse if he saw Sam doing shots with the guy. Jesse shrugs and says Sam does shots with everybody. The next time I pass him he seems a lot drunker than he was moments ago. He asks how much the free shots are. I tell him that at our prices we'd go broke giving away the bar.

"But you know the bossman's getting rich, right?"

He doesn't believe me when I assure him the boss-man really isn't getting rich. He's teetering on belligerent now and takes forever gathering his belongings to leave once it sinks in he won't be getting one on the house.

Petty's record ends and I put on something else. The guy takes another five minutes fumbling with his zipper by the door before finally walking out.

RIP Tom Petty.

Roky Erickson

I'm always haunted by the scene in *You're Gonna Miss Me* where Roky Erickson sits in an armchair, wearing shades, with a bunch of radios and TVs all on at once to try to drown out the voices in his head, trying to get some sleep. So I felt some trepidation going to see the man play in person. I had no interest in watching a sick person struggle on stage. Fortunately this was not the case at the Abbey Pub in 2008.

When his band was going, Erickson was fully on. He had no trouble singing about his demons and monsters. Between songs he was more tentative. He stood looking around, as if waiting to be plugged back in. Then the next song would start and he'd come back to life.

Robert Belfour

On a makeshift stage with tent covering to shield him from the pouring rain, the old bluesman took a long time tuning his guitar. Maybe it was the weather or something inside him, but he just couldn't get his instrument to sound the way he needed it to. A younger man kept taking the guitar and fiddling with it and handing it back, but each time Belfour would shake his head and hand it back because it still wasn't right.

Then he started playing, and no one could've known anything had ever been wrong.

NOT MUSIC

Since my first book was published in 2011, I've often gone to readings and other lit world events. I always bring my sketchbook. A writer reading what they've written or a comedian doing their act isn't ever as exciting as a musician playing music, but it's still a performance and, just as with bands, drawing while it's happening helps me listen.

Chet Weise

At the Empty Bottle sometime in the early aughts, Chet Weise played his guitar, balancing atop two amps, hitting a switch making sound come out of one, then the other, making his one guitar have a call-and-response conversation with itself.

Sure, he was another scraggly sideburned white guy in 70s finery trying to access old-time blues. But he was having a good time and he looked like he meant it, like there was more to it than a costume. That band was called the Immortal Lee County Killers after the part of Alabama Weise is from.

I got to talking to him a few years later at the Deep Blues Festival, on the border between Wisconsin and Minnesota. He had no band at that point but got on stage in another 70s-style suit and banged away at his guitar to a prerecorded rhythm track as the rain poured down on all of us.

One time when Shay and I were driving through Nashville, Chet took us to Bolton's Hot Chicken—a simple shack with picnic tables in the dining area, with a partial view of the dark kitchen with men working over blackened skillets of burning chicken parts. Hellish work for heavenly results. Then we went to a bar you could still smoke cigarettes in. I smoked almost twenty years but had quit five years prior. It was so strange to be in a room filled with hanging smoke and to think about how much time I'd spent in such rooms not thinking a thing about it.

I finally got off a sketch of Chet, but not in a smoky

rock club or a legendary chicken restaurant. He was at the Poetry Foundation in Chicago to promote a poetry collection Third Man Books was putting out. Chet got his master's in poetry and spends a lot of his time in lit-land these days. Afterwards I took him to Rossi's—the only bar anywhere near the Poetry Foundation which even remotely resembles the joint he took us to in Nashville.

No matter how legit Chet gets I'll always remember him rocking back and forth while riding two amplifiers, wailing away on his guitar.

Yow

I never saw the Jesus Lizard live, even though I've had tickets a few times. Each time something went sideways. I'd be sick, or in a shitty mood, or I'd decide I didn't want to go to the club they're playing. (I also have a contrary streak which makes me want to doubt it when so many people count a thing the best of its kind. There are many who consider the Jesus Lizard the best live band there ever was. I value many of their opinions but may never find out for myself. And yet I love their music whenever I hear it.)

The only time I ever saw singer David Yow perform was at the Middle East in Cambridge, Massachusetts with a band called Qui. He was sort of a guest star. He took a wooden chair and smashed it to splinters. I have no recall of the music that night.

Then some press put together a Jesus Lizard book and Yow squirmed through a publicity stop Q & A at the Bottle. I got off a decent sketch.

There have been a couple reunion shows since,

but I haven't even bought tickets. Better to imagine that mythical band rather than risk disappointment, or worse yet at this point, the lack of it. What if all those people were right?

Slaughterhouse

I went to Stanley's Tavern for a book-release party. Stanley's—situated at the corner of 43rd & Ashland, right by one of the entrances to the Union Stock Yard—is one of the oldest bars in the city. We were there to celebrate *Slaughterhouse* by Dominic Pacyga, a history of Chicago's stockyards.

I got there a little early but the place was already filling up and Pacyga was signing books as fast as the folks from U of C Press could sell them. By the 6:30pm start time there was nowhere to stand, let alone sit. It

was clear there wouldn't be much reading or discussion. A few people bought books and just turned around to leave—a problem any writer with a new book would love to have. Then again, it wasn't the typical lit event crowd. Most were older and seemed to have more ties to the stockyards than the world of letters. Many were either related to Pacyga, or had known him since childhood.

Bill Savage, who was to lead the talk, did his best to quiet the crowd long enough to introduce the writer and assure everyone that they could go back to their drinks and conversation in a few short minutes. Then Pacyga read from his book, perched on a rung of a barstool so he could be seen just above his audience.

Then it was over.

Marc Maron

Marc Maron is the first stand-up I ever paid to go see. I got hooked on his amazing interview podcast and wanted to see what the man considered his main gig. It wasn't what I pictured a comedy show to be. Maron's not really a ha-ha joke guy. He drills down into his pre-occupations and neuroses in extended, often hilarious bits. He projects a vulnerability which is rare among the showbiz set. I enjoyed it enough to go back the next

couple times he came through town.

Over the years of listening to his show twice a week, I've learned that he and I have a couple things in common. He worked at Edibles in Brookline a year or two before I did. (Edibles was a breakfast and lunch spot a few doors down from my elementary school. I worked there weekends in high school. Everybody else there was older and seemed to be on a destructive track. There was a lot of drinking and theft in that place. I imagine it was no better in Maron's time.) His comedy career started in Boston but he left soon after. I couldn't wait to get out of that town either.

Our other commonality is an obsession with music. It hovers around the edges of Maron's life. He's always talking about his guitars, and sitting in with musician pals. Many of the people he interviews are involved in the business too. I haven't played an instrument in years but music is never far from my mind.

It's my road not taken.

Adam Burke is a friend of a friend of a friend. We were at the same Thanksgiving meal once. It was a kick to see him open for Maron on one of his tours. He does spots around town all the time. But despite actually talking to Burke several times, I know a lot more about Maron.

One of the traps of our time is the illusion of intimate familiarity with complete strangers. Social media and podcasts make us feel that people like Maron are our actual friends. They're not. I have a stack of unanswered email to Maron to prove it. Because he has a soapbox and overshares, thousands of us think we're his close friends when nothing could be further from the truth. Still, strangers who speak to us through speakers make us feel less alone, even if they will never be our friends.

You'll Do Better Here

I rented a car and drove to Toledo. My friend, John Hodgman, was talking on stage to his friend Sarah Vowell there, which seemed like reason enough to go. I hadn't been driving much, so it felt like a special occasion.

The route from Chicago to Toledo is pretty much a straight shot east and utterly unremarkable in terms

of scenery aside from the industrial remnants of Gary, Indiana, which don't require a trip to Toledo to see for a Chicagoan. Forgettable scenery leaves room for a mind to drift. I can't recall much of that drift now but know it didn't follow a pattern likely to be inspired by a walk or city bus ride—my usual modes of transport. I listened to

podcasts, too. Marc Maron talking to Ron Perlman, Terry Gross talking to Ray Liotta, and Brad Listi talking to Nicole Dennis-Benn. There wasn't much traffic up until about five miles from my exit, when the tollway cut down to one lane for construction. We crawled for half an hour.

Because I no longer had a smartphone, I'd printed out the Google Map directions, just like in olden days, but I managed to make a wrong turn anyway. I tried to correct course on my own but quickly gave up and asked for help at a gas station. (Not having the internet handy forces one into more face-to-face interactions, which is not a bad thing for antisocial types like myself.) As I passed under the tollway, Toledo's city limits greeted me thus: *You'll Do Better Here.*

The Stranahan Theater is an enormous brutalist edifice. I drove up to it from a side entrance. The path was decorated by a Private Property sign and a couple realtors' For Sale ads. The place looked forlorn and deserted. Only a few cars in the vast lot and an old LED sign out front, periodically announcing that Pat Benatar and Dream Theater would be gracing the Stranahan's stage soon. It was about an hour before doors would open, so I drove off in search of food.

Before leaving Chicago, I'd searched online for Toledo's culinary offerings, but nothing jumped out at me enough to print out more driving directions. Leaving the Stranahan's lot, I turned in the opposite direction from where I'd come and quickly passed a completely ordinary-looking establishment called Ideal Hotdog. I doubled back and went in. I seated myself by the window and a friendly waitress asked if I needed a menu. The

other diners were a couple solitary old men and a young family. I doubted any of them needed a menu. I ordered two Ideal Hot Dogs with fries. They arrived in front of me moments later, each covered in chili consisting entirely of crumbled meat. I texted John, and he asked if I could bring him a hot dog as a prop for his show.

I've known John since high school and it's been quite a thing to watch his star rise. Each time he comes through Chicago his audiences grow, and his stage act evolves and deepens. But Toledo's not Chicago, and the almost-deserted parking lot suggested this show would not be a rousing success. In the lobby a few fans milled around. Elderly women with nametags wandered about, making preparations to open the box office and stocking the snack bar with potato chips. One came out and announced that they wouldn't be taking credit cards for ticket sales. It seemed a far cry from the typical Chicago Hodgman appearance, which usually sells out and seems carried along on the palpable excitement of his adoring fanbase of bespectacled nerds.

In the VIP area to the side of the lobby, I handed John his hot dog and we made plans for drinks after. To my surprise, by showtime the cavernous hall was more than half full. John's polish worked well with Sarah's deadpan reticence. Each read from their work. Sarah's list of odd world despots included the three False Dmitrys, who were pretenders to the Russian throne and who I was very happy to learn about.

One of my favorite things about going to see John perform is the signing line afterward. Last time in Chicago, this meet-and-greet lasted longer than his actual show. I love to sit just off to the side and watch the fans in queue psyche themselves up to meet their idol. What do you say to someone who means so much to you but doesn't know the first thing about you? John was unfailingly gracious with these people because perhaps he wasn't so far removed from knowing what it was like to be in their place. At one point, Sarah remarked in mock annoyance, "You really take your time with them, don't you?"

We drove to a deserted bar in downtown Toledo. Then crossed the street into a slightly less deserted one. There was barely anyone about on the streets by 10:30pm. A couple of John's friends who drove in from Columbus joined us, while Sarah begged off, citing exhaustion; she'd reached her socializing limit for the night. After a couple rounds we called it a night, too. I had a four hour drive back in front of me, and I wasn't about to do it drunk.

Twelve years driving cab and another three delivering Thai food have made driving almost effortless for me, but I was tired enough to pull into a rest area and take an hour nap. I made it back to Chicago by 4am, exhausting the rest of the saved podcasts on my iPod.

I can't say what Toledo meant with its *You'll Do Better Here* motto, and I'll take a Chicago hot dog over an Ideal one every time, but I was glad I made the trip.

Hallelujah! Sing-Along Gospel Brunch at the Polo Cafe

The Polo Cafe is at the end of my block but I've only been there a couple times, and never on any day but Sunday. I never think to go any other day because Sunday brunch at the Polo is such a singular experience. You get a lot more than pancakes or hollandaise-smothered something.

There's a large chalk mural on the south wall of the restaurant depicting Bridgeport history. Along with portraits of Chicago mayors hailing from the neighborhood, there are drawings of notable buildings and streets. The rest of the decor consists of historical photos and knick-knacks.

All the servers are very young and tentative. They act like they're playing at or practicing being waiters, rather than actually being waiters. They're like neighbor kids helping serve after church as part of worship, rather as a job for money.

Each table has a thick hardcover hymnal, and if you don't catch the room mid-song as you enter, you find out what these hymnals are for minutes after being seated.

A round-faced man with a headset mic is seated at an electric keyboard toward the back of the room. He welcomes new arrivals and urges us to open our books to this or that page and sing along. Before coffee is even offered he begins crooning some ode to the Almighty. A benevolent but imposingly large portrait of Old Man Daley looks on approvingly from the wall past the organist's left shoulder. A few of the diners chime in between

bites of french toast.

If a guest dares to order Eggs Benedict, a candelabra and portrait of the disgraced ex-pope will accompany their plate. It may be the most solemn and bizarre ritual in a place which revels in them.

I'd go to the Hallelujah! Sing-Along Brunch more of-

ten if it didn't weird me out so much. I hate to bring up David Lynch because he's become such a shorthand crutch of a descriptor for any bizarre small-town America type behavior, but I truly could see the Polo Cafe belonging in *Twin Peaks*, or along the Lost Highway.

I hesitate to go because I don't want to just be there out of perversity or smart-aleck irony. I believe the people who run the Polo are sincere in their religiosity, and I have to respect them for that. At the same time, it's an uncommon Sunday morning that I'm up for a steaming side of faith with my steak and eggs.

BACK to tHE BARS

Running/Pill

I got up on Monday morning wanting to go see some bands. Finding listings and recommendations without Facebook or Twitter takes a bit of work. You actually have to go to venue sites or trusted news outlets to see what's available. Today, the *Chicago Reader* recommended a Brooklyn band called Pill. The writer said the EP they released last year was a masterpiece, anointed them heirs apparent to Sonic Youth.

I got to the Hideout way too early, as usual. There weren't many people at the bar, and some performance

art/talk show thing was wrapping up back in the Chinook Lounge, so bands hadn't even set up yet. Guys in winter coats darted in and out hauling amps and instruments. A woman was looking around uncertainly, holding a box of records. I pointed her towards the counter where most bands set up their merch table, next to the ATM, just before the swinging doors back to the lounge. She turned out to be Veronica, Pill's frontwoman.

One day maybe she'll have roadies to schlep her shit, but that day she had to be her own roadie. (I like

bands that still have to carry their own gear, because watching them do so underlines the very thin line between them and their audience. It makes the moment they step onstage and plug in that much more magical.)

I love the saxophone in jazz but it's often fatal for rock bands. Think the E Street Band. The horn in that band is the sound of a million good-time beer commercials. Thankfully, the sax man in Pill would have a hell of a time selling a single bottle of Budweiser. He's from the James Chance no-wave school and used his instrument as much to create feedback squalls as melody lines. The singer was the right amounts angry, funny, and blasé. Guitar, bass, drums, and sax all took the lead by turns. Whether or not they're the next Sonic Youth, they were a damn good band.

The openers, Running, were from here. They'd been on my radar for a few years, but this was my first time seeing them. They played skuzzy, feedback- and reverb-mad rock. Their guitarist played most of the set bent so far over his instrument I wondered whether it hurt him to stand upright. When he took his turn singing, his gaunt eyes, greasy black hair, and long nose immediately reminded me of noir movie maniac Timothy Carey. For the rest of the time Running was onstage, every time I looked his way my mind's eye ran scenes from *The Killing* or *The World's Greatest Sinner*. For this band, seedy menace is sort of their thing.

Afterwards, I bought records from both bands and went home. That morning neither Pill nor Running were part of my life. I've listened to their records a bunch since, but who knows how long the memory of that

show will linger? It will certainly fade over time; even the recordings themselves rarely hold the same charge. But at their best they'll keep reminding me of the night.

I may as well have been back in the Paris Metro station drawing buskers. Thirty years on I'm still chasing the same thing. I make lines in my sketchbook in reaction to men and women strumming guitars or banging on drums. I try to catch a bit of the motion, knowing all the while my drawing will never do much more than hint at what it's like to be there in person. But that's all an artist can ever do: capture a suggestion of a real thing that happened.

The Road Not Taken

Music is the purest art form because it's carried through the air. No paper, canvas, walls, ink, or paint are needed. Once it's out it travels from one body over and around and through other bodies. Music can be anywhere, and is probably everywhere, because even its absence is a kind of music.

I'll always wonder about music. Would I have stuck with it if I wasn't forced to play an instrument I loathed? To this day I won't go to an orchestra hall because the eight years of violin were such a trial. I fought it the whole time but would still get upset when I was passed over in recitals or at orchestra, even though I barely practiced and didn't deserve praise for my half-assed efforts.

All these years I've kept it close. I'm always listening, always trying to find new sounds. When I started bringing a sketchbook to every show it was a way for me to feel closer to what was happening up on stage. Filling up dozens of books with drawings of guitarists, drummers, horn players, and keyboardists has made my listening active. Whether these drawings are worth looking at divorced of the context of their making is not for me to judge. But I know that making them adds a dimension to concert-going which I miss when it's not available—when the venue's too dark, too crowded, too chaotic, or too hot for me to draw. Or when I get there too late to stake out a good spot.

Because I tend to go to the same clubs and am al- most pathologically early most of the time, this rarely happens. But when it does, it feels like the night is miss-

ing something. Holding my Parker Jotter at the ready to catch some bit of physiognomy, or to indicate where a mic stand is in relation to a bass drum in relation to an amplifier—it's a way for me to nail down for sure that I was there.

For all the writing I've done over my life, I've never kept a diary or personal journal. I don't believe in writing—or art, for that matter—which isn't for sharing with others. Art is communication. I see no other reason to do it. But the sketchbooks I take with me everywhere are a sort of daybook. A place to note the places I go and the people I see.

Writing this book was an attempt to wrench memories, associations, and ideas from the hundreds of thousands of drawn marks I've made in the little blank books of my life. In all my sketchbooks, it's been the subject I've returned to most often—people playing music.

The sad fact is that music isn't describable in words or in pictures. It doesn't need either inferior language to exist. And yet we keep trying to capture it with brushes, pens, cameras, typewriters, and recording equipment. Just because we're bound to fail—and know it—is no reason not to do it. We'll always dance about architecture, no matter how convincingly friends try to talk us out of it, or how brutally we're mocked for it.

I'm resigned to my stage being a piece of paper, and my audience taking in my performance long after it's over—if I choose to show it. I'm not the type of person to live in the moment, open for others to see and hear everything I do. As many times as I've watched musicians play, I still have no clue how they do it.

That's why I'll always bring my sketchbook to the show.

Maybe I'll figure it out one day. But I'm not holding my breath.

LIST OF DRAWINGS

All drawings done in Chicago unless otherwise indicated.

THANK YOUs

I pitched the idea for this book to many publishers over many years with little to no response. It wasn't until Bill Hillmann reminded me about Jerry Brennan and his Tortoise Books that things got rolling. Jerry's sincere and as straight an arrow as I've come across in a business full of weasels and blowhards. He's been a joy to work with. (A damn good editor too.)

Bill Savage has been an early reader and editor on all my books (published and unpublished.) I'm always grateful for the way he wields that red pen.

Sheila Sachs was a great help in guiding this novice about the infuriating, unintuitive universe of InDesign. Whatever the final results, this book is light-years better because of her know-how.

I'd like to thank Parker Pen Company for making the Jotter. All but a couple of the drawings in this book were made with that beautiful pen and I've never been without one on my person over the past thirty years.

My parents, Alex and Nora Samarov, have been unfailingly supportive to all my creative efforts, whether I deserved it or not. I'm stupid lucky to have them in my life.

I'm grateful most of all to the guitarists, drummers, pianists, singers, horn players, and all other musicians without whom neither this book, nor what passes for my mental or emotional equilibrium would be possible. I'd be dead without you, so please keep playing.

CPSIA information can be obtained
at www.ICGtesting.com
Printed in the USA
JSHW050406010622
26529JS00001B/46

9 781948 954099